a few places

near home

Frank Prem

a poetry of passing time

Publication Details

Title: A Few Places Near Home

ISBN: 978-1-925963-90-8 (pbk)

Published by Wild Arancini Press Copyright © 2023 Frank Prem

All Images Copyright © 2023 Frank Prem

All rights reserved

Images were captured using a mirrorless Canon EOS RP camera.

Contents

Right here and right now, I name you
beautiful.

About *a few places near home*

a few places near home is a picture book that is also a poetry collection, and serves as a celebration of a few picturesque places that lie within easy walking distance of my home in Beechworth, Victoria.

The images I have taken for this collection are drawn from the following locations:

The Rail Trail walking track (which runs between Beechworth and Everton).

The Beechworth Gorge.

Ingram's Rock.

Lake Sambell.

The theme of this collection is *the passing of time*, which is always - to me, at least - also suggestive of the evening and of Autumn. The beginning of the end of the day and the start of a later season.

Particularly apt as I grow older and see things with slightly different eyes than I did once.

FP

2023

a few places near home

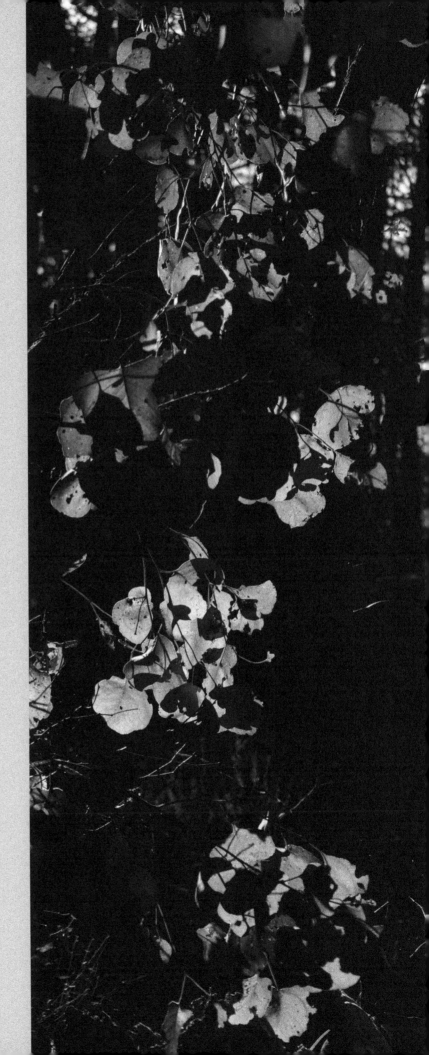

golden green
(I sing of this)

I sing
the lesser song
of
a lesser man
yet
the sun shines
through my leaves

and
it is golden
in the green

shows the heart
that is lying there

before my eyes

at my feet

and in the air –
filled –
all around me

I sing of this

I
with my lesser songs

I sing
of this
golden green

in my voice
the golden green

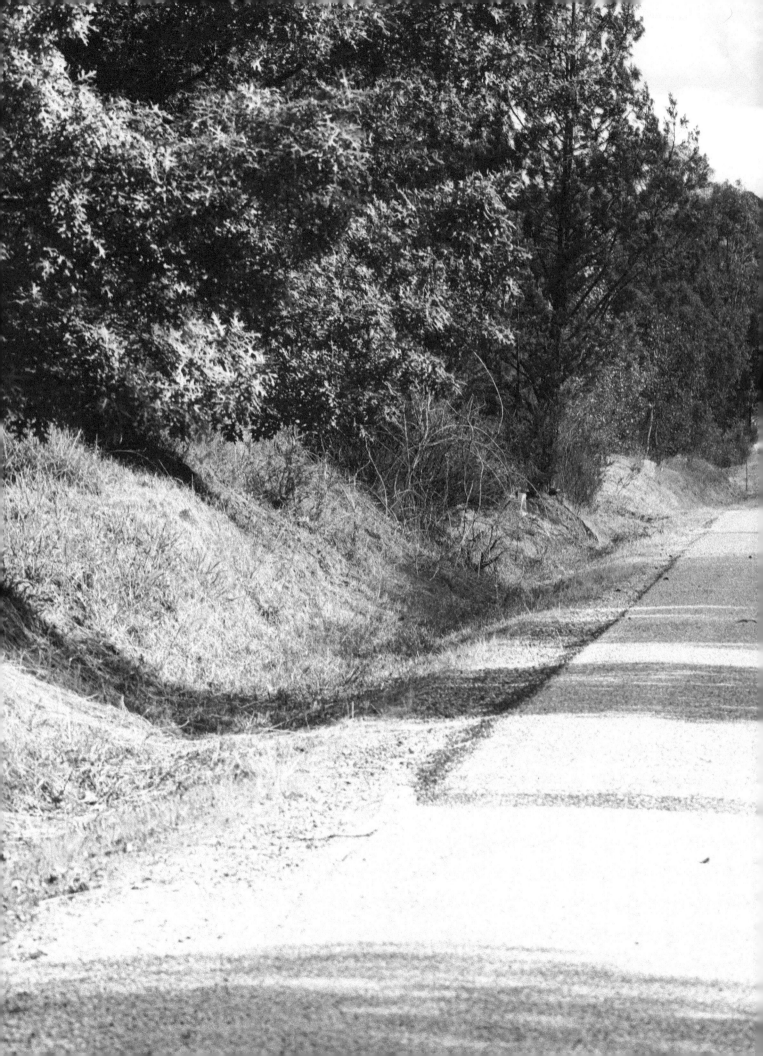

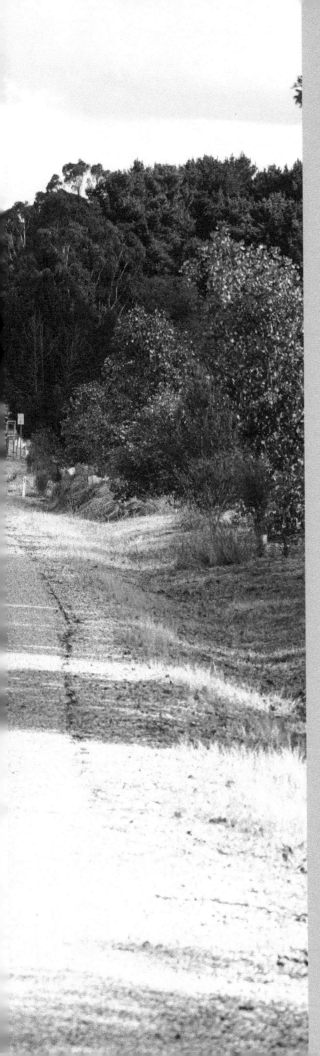

any place
(might be home)

every road
is
another way

a path
that leads to home

one step . . .

then
one step more

the only way
is to journey
on

something waits
in the distance

someone
calling your name

every road
is another way
to go

every place
a might-be
home

watch the show
(from home)

the show
is on the horizon

the game
is over there

I do not need
to think
of that

I
need not care

how far
is *far enough* away?

I
do not know
but
I take my comfort
where I can

the show
is on the horizon

I watch
from home

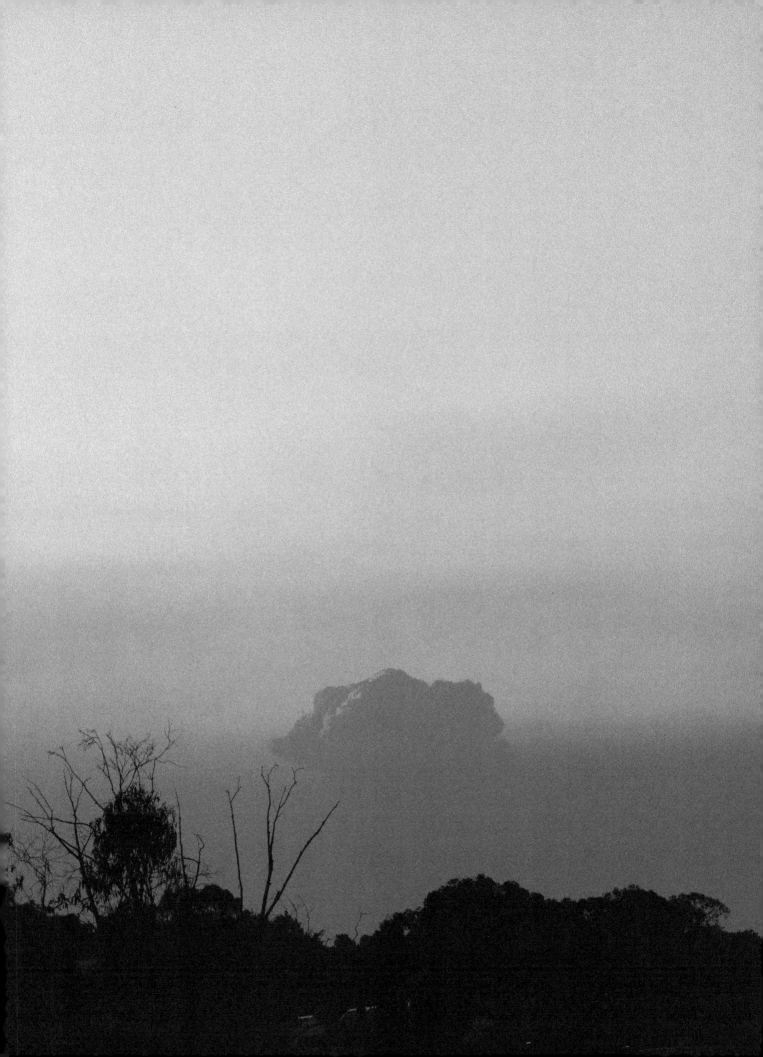

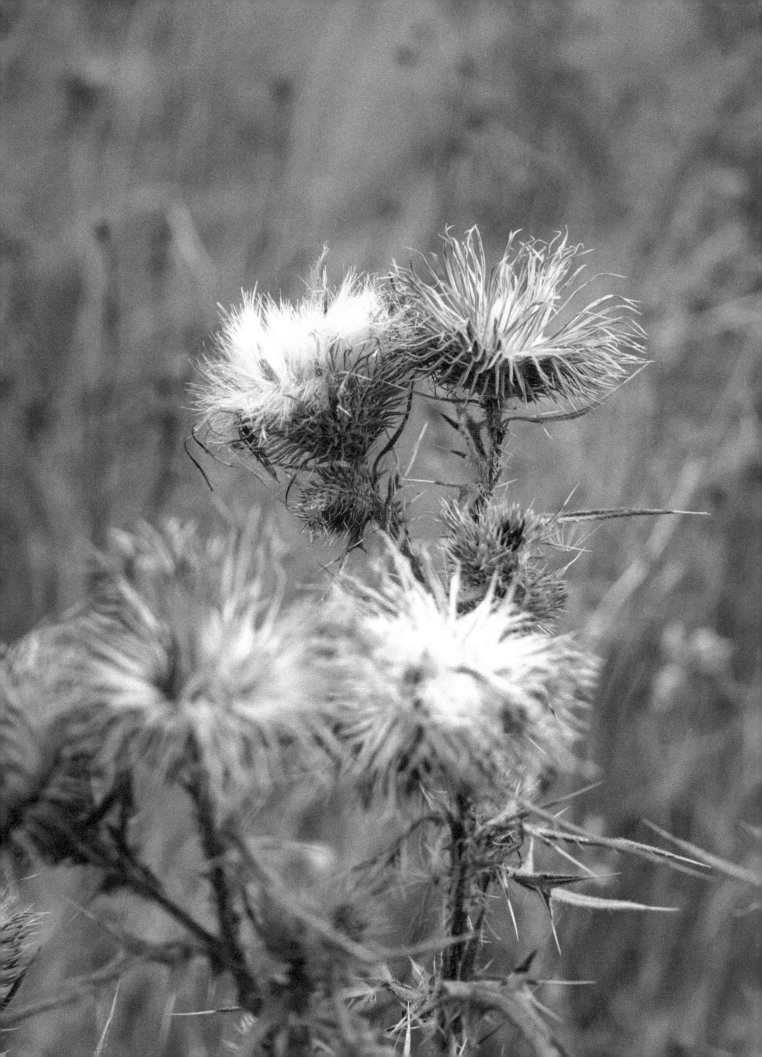

weed
(once)

hello *scruff*

hello *fluff*

my spiky friends
of the roadside

how you remind me
of what I was
and who

such days!

thoughtless

carefree

prickly
and bristling

when
did I stop being
that weed?

become
this man?

a canvas wide of words
(not enough)

it comes

a white nib
to mark the blue

couplets
to spread the word
wide:

contrail

to shout the poem
in delay:

contrail

the sky
is a canvas wide

a page

these words . . .

not nearly
enough
to fill it entire

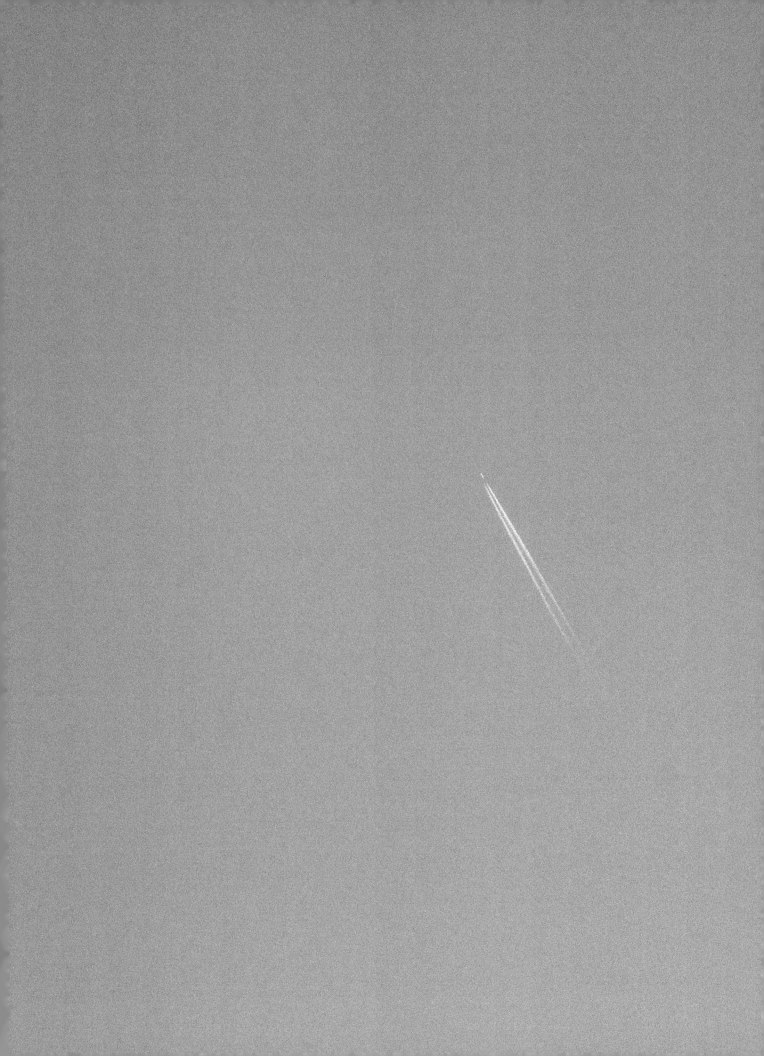

enough
(for today)

if I will
the day
to stay . . .

will myself
to never
die

what
will become
of tomorrow

without hope

without
desire
for the new
and
for the change

every day
is new
again

today is done
when the sun
goes down

and even
what I have
right now . . .

perhaps

must be
enough

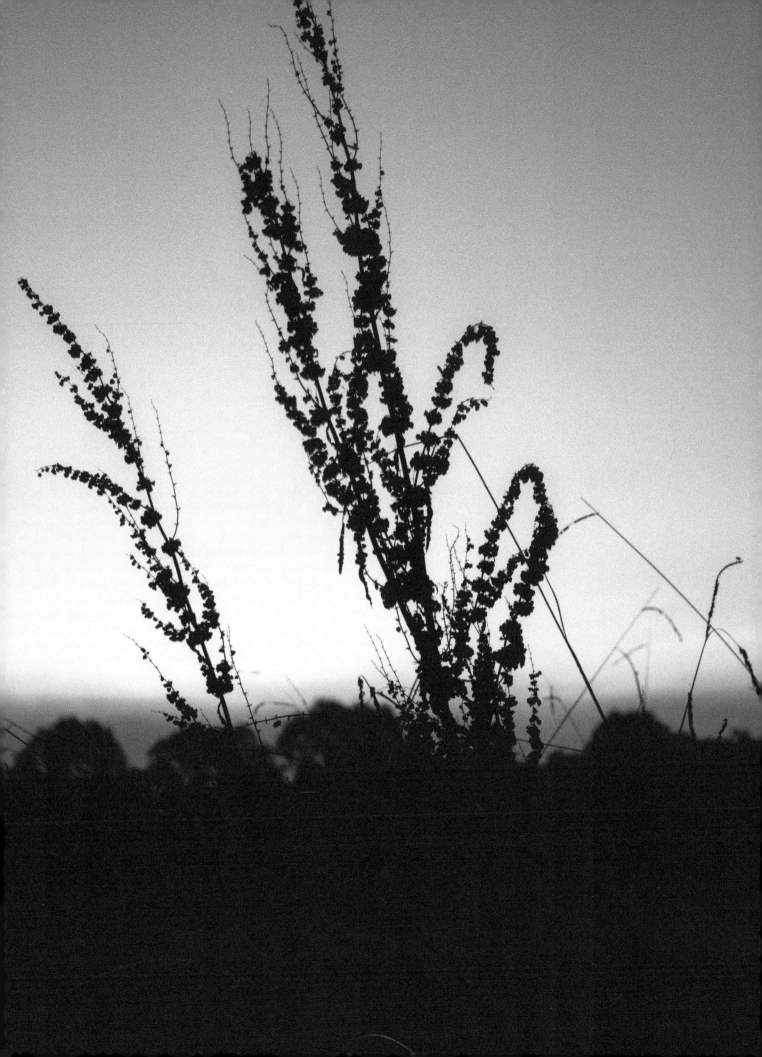

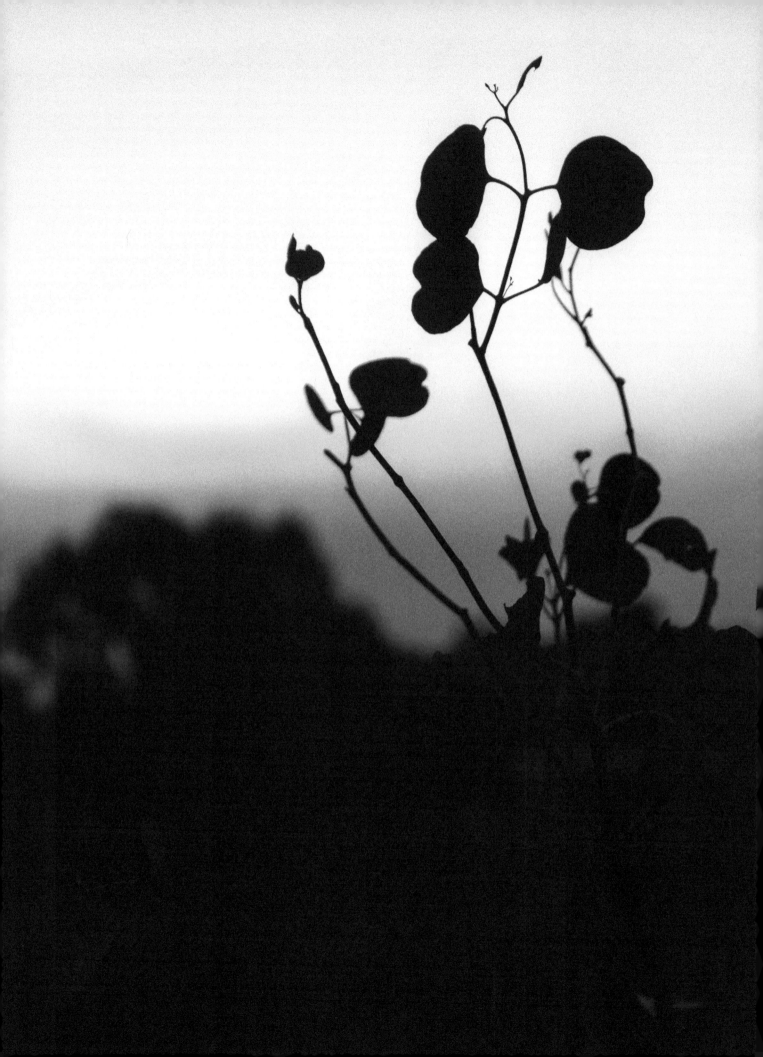

time
(until then)

every day
begins
and ends

a breath

a sigh

the dawn
and dusk

a rhythm
between dark
and light

a time to work
a time
to sleep

all time
to *be*

all time
until then

watch within
(the passing time)

stand up
inside
the passing time

feel the changes
that you meet

from green leaves
to hollow straw

the breeze
remains
the breeze

that kissed you
in early
spring

that tastes -
still now -
of summer wine

that shivered you
when the sun
went down

and chills
as darkness
encroaches

stand up
inside
the passing time

watch and marvel
all that you
have been

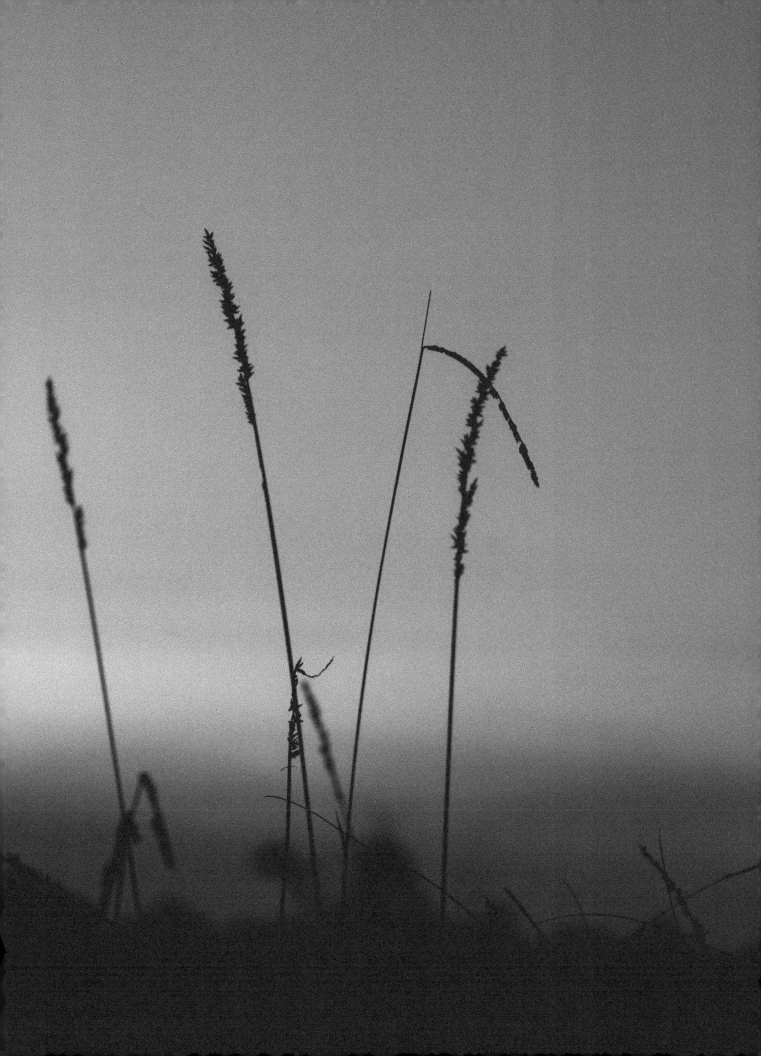

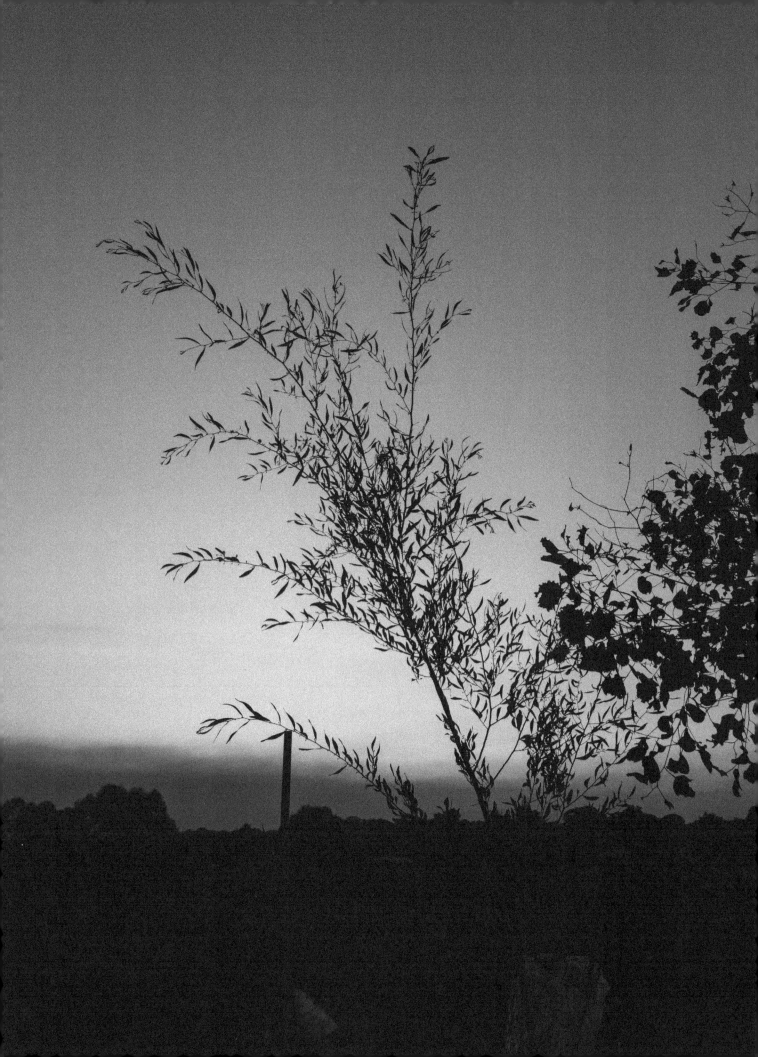

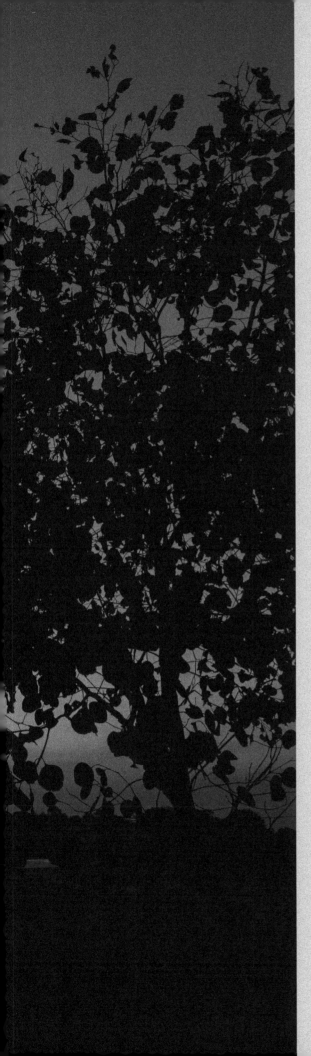

cool truth
(in the night)

the hue
of the day
is turning
to night

all
I have known
is fading

night
is the time
for discarding
illusions

that dance
in a shimmer
of the sun

in the night
cool truth
is worth more
than such gold

toward tomorrow
(I will turn)

the red night
is falling down

the day
almost done

I can barely see
the way
toward tomorrow

perhaps
the need
is to turn around

the west
possesses yesterday

east
the day to come

yet
I am held
by the passing
of today dreams
into darkness

maybe
when they have fallen -
their hold on me
broken -

maybe then
I can be
free enough
to turn . . .

toward tomorrow

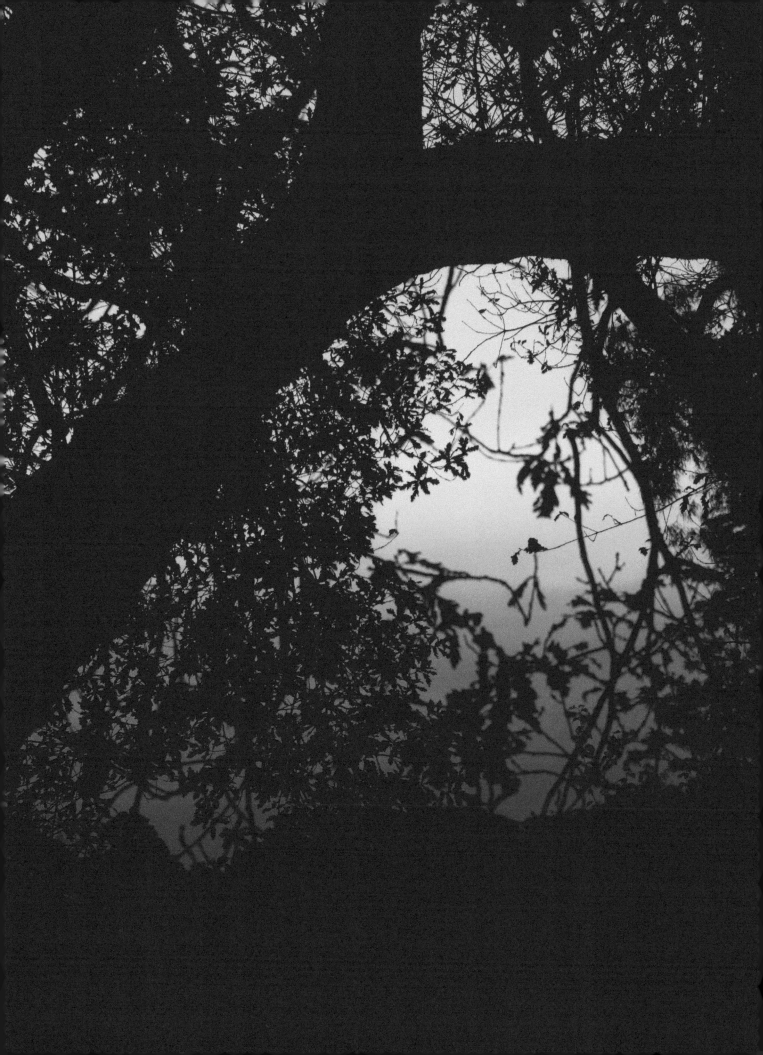

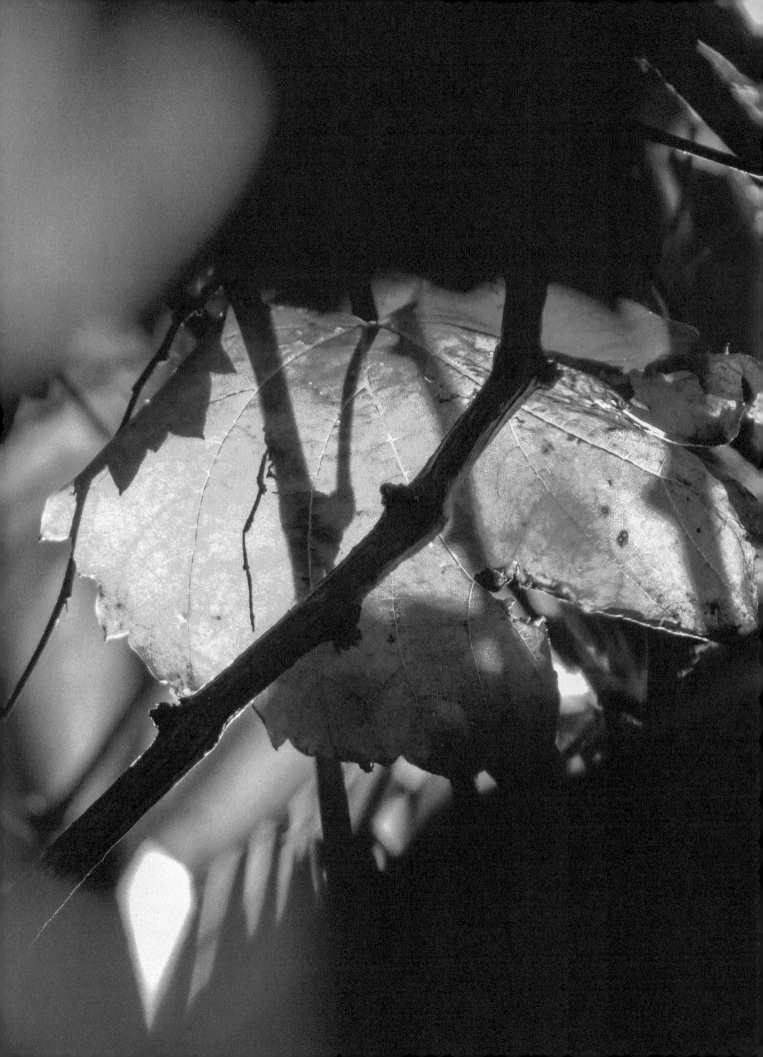

drink it up
(the warm inside)

night comes
but
the last light
still shines

the colour
of gold
the colour
of ruby wine

drink it in

take it up

the night
will come
but you and I
will be warm
inside

I see dragons
(some days)

some days
are dragons

I see them
fly

on breezes
that
no one can see
and
no one can feel

some days
time drifts by
almost unseen

almost
unfelt

it is only
at evening . . .

when the sun puts colour
into cloud

I see the day
that might have been

all the things
I
might have done

then
dragons drift
across the sky

before my eyes

some days
I see them

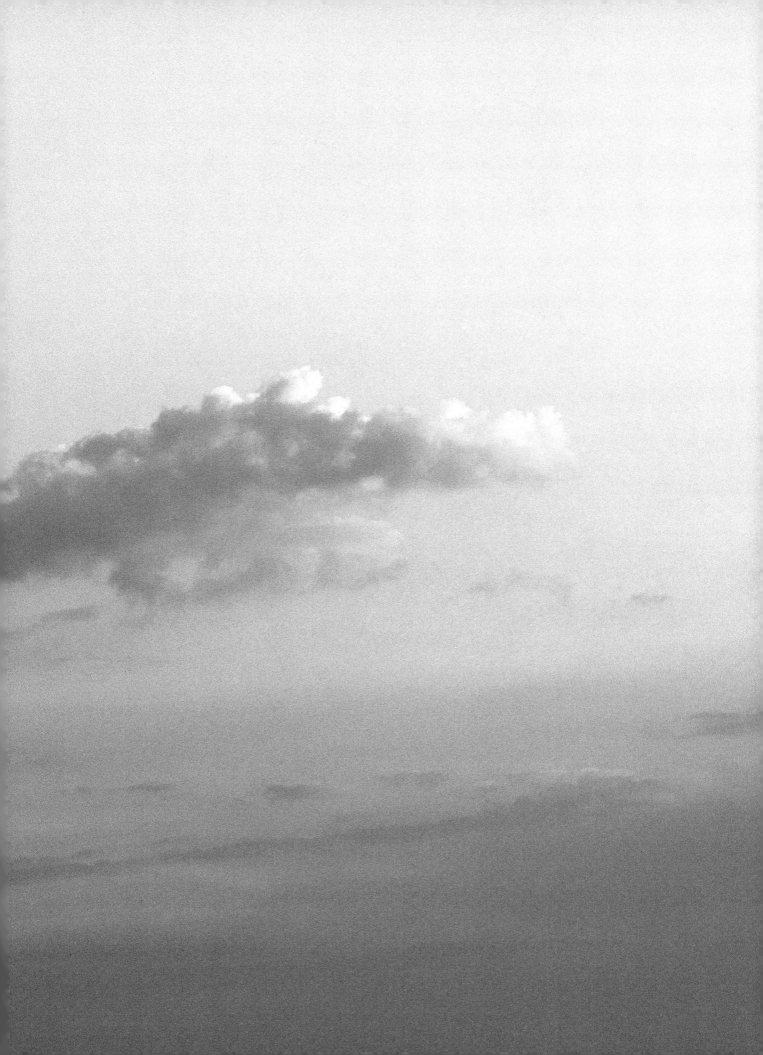

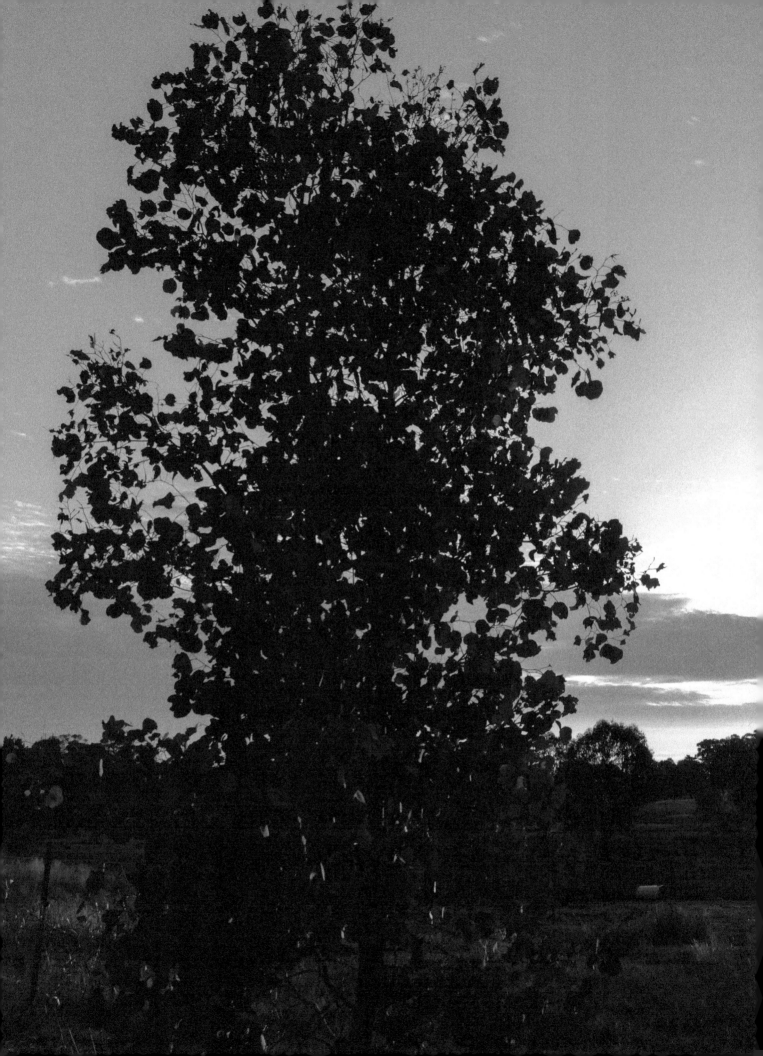

here I dawned
(not yet)

a dying sun

with hand
outstretched
I close my eyes

let it touch
me

this sky
is in
my blood

these stones . . .

this *dirt*
are what
I am
here
I dawned

and here
I
shall die

but
not yet

not tonight

I close my eyes

let it touch
me

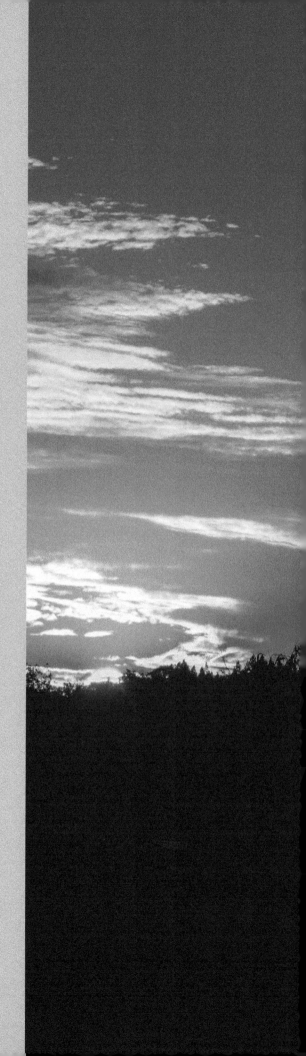

glory
(one last time)

fade away
in glory

leave your image
in their eyes

the day is old
the day
is long

sweet memories
in every one

hold the light
and gleam
the eyes

leave your image
burning
for them

one last glimpse
of glory

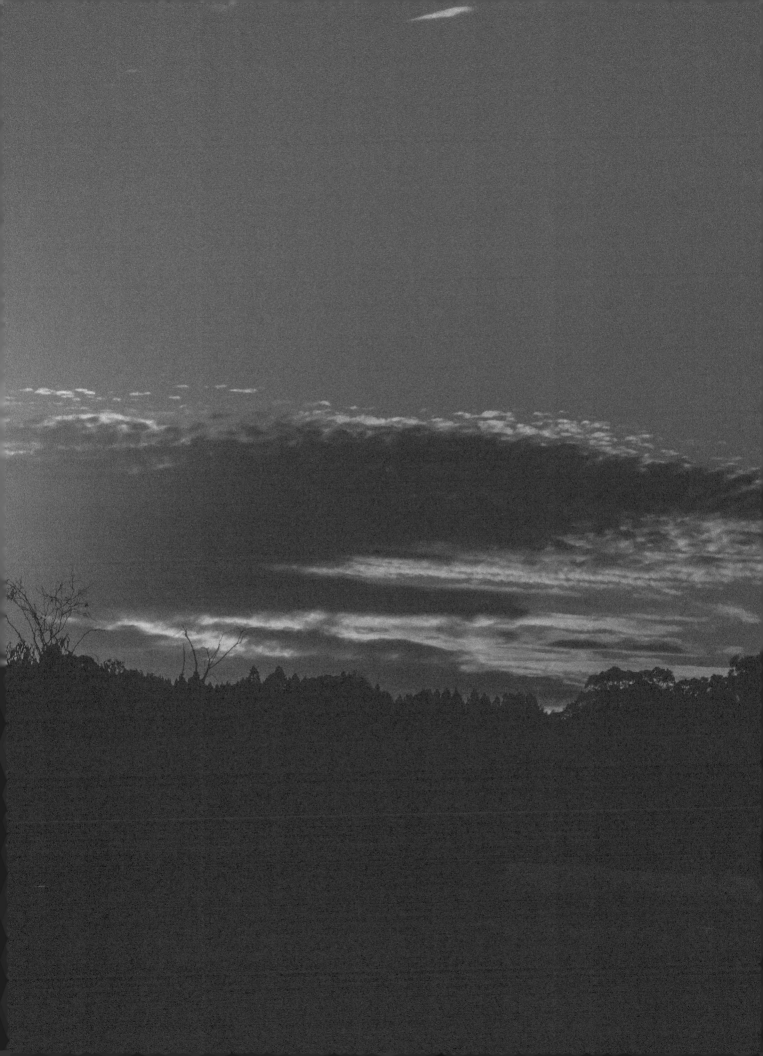

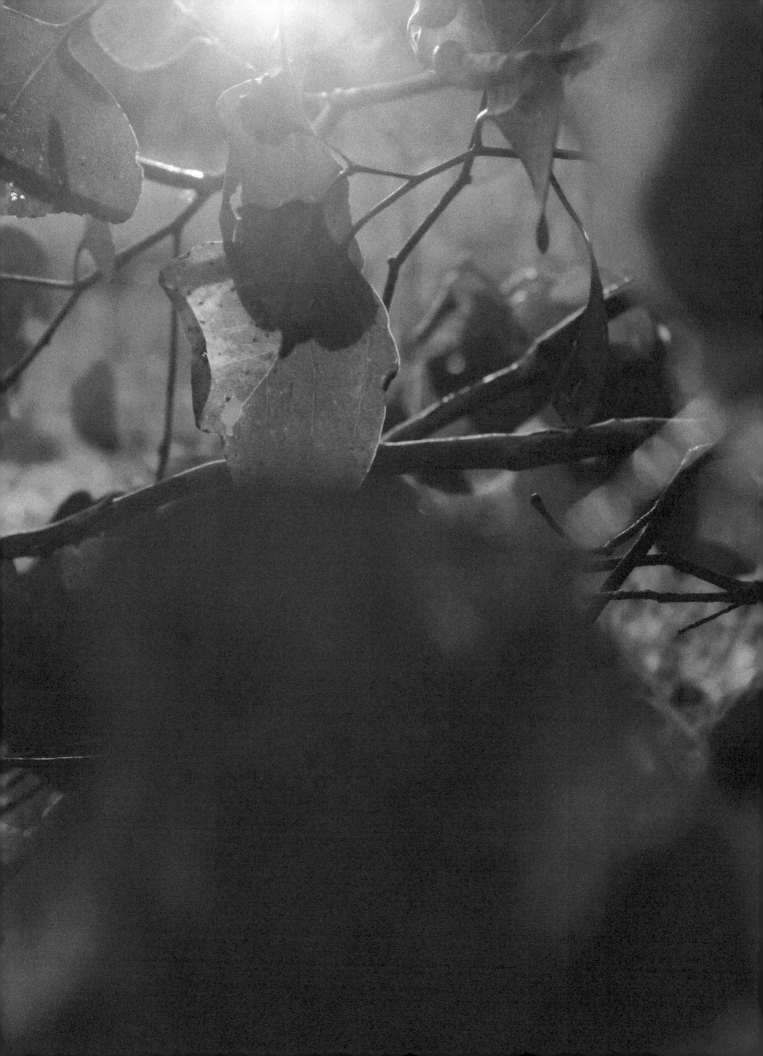

sustained in a look
(a kiss)

there is
a kind of love

that makes a colour
warm

some
little heat
that is nearest
to affection

like a hug
that does not
hold

a regard
that *elevates*
by being

I feel your look
and *I*
am warm

your kiss . . .

my leaves . . .

sustain me

good times
(with friends)

a life
well lived

fleet friends
who stayed

oh yes
it has been
a good time

oh yes
I
have had
a good
time

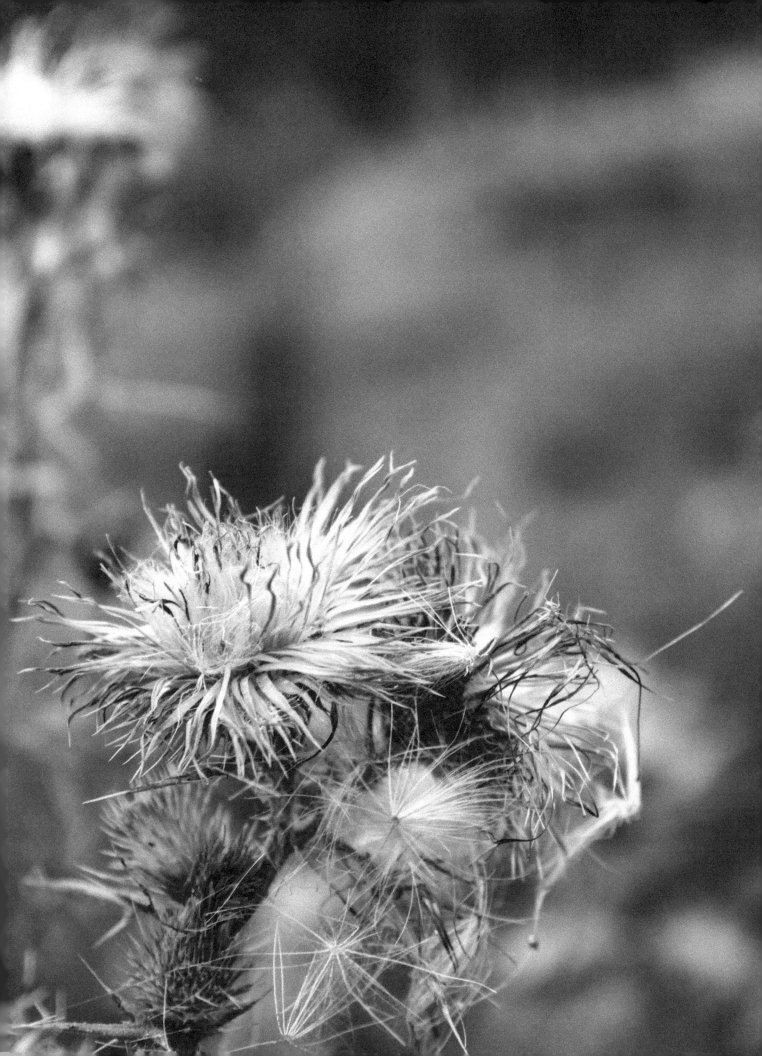

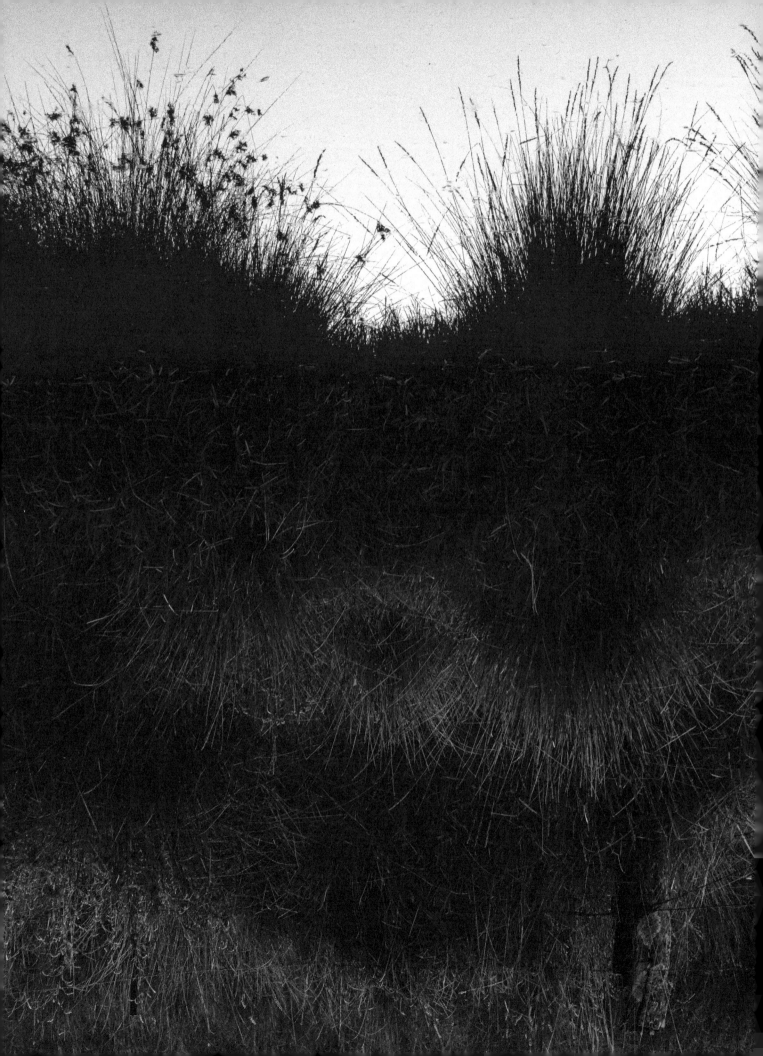

all right again
(one day)

the whole world
is
upside down

rotated . . .

rotated again

how
can we make sense
when top
is bottom?

is it true
as well
for right
and wrong?

sometimes
they both look
just the same

~

*which is the water
which
is the sky?*

*where is the land
I need
for my feet
to stay dry?*

*I have been standing
on my head
too long*

*sniffing the wind
to find the taste
all wrong*

*why
is the water
up
so high . . .*

~

there are too many
of these
questions

I am
a simple man
who has no answers

none at all

but
wishes the world
looked right
again

hopes
the world
will *be* all right
again

one day

sentinels
(in passing)

a single
blade
of kangaroo

a sentinel
gazing

we watch
each other
while
I pass

none
escapes
without our notice

I
with camera
aimed
all round

sentinel 'roo
just watching

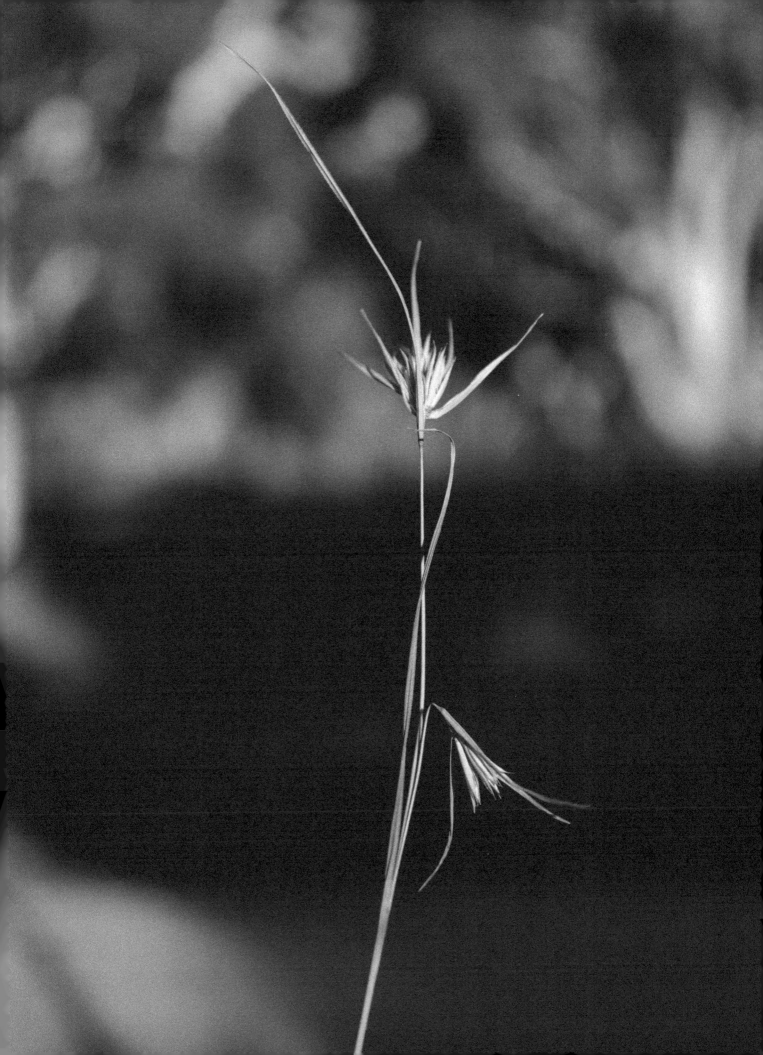

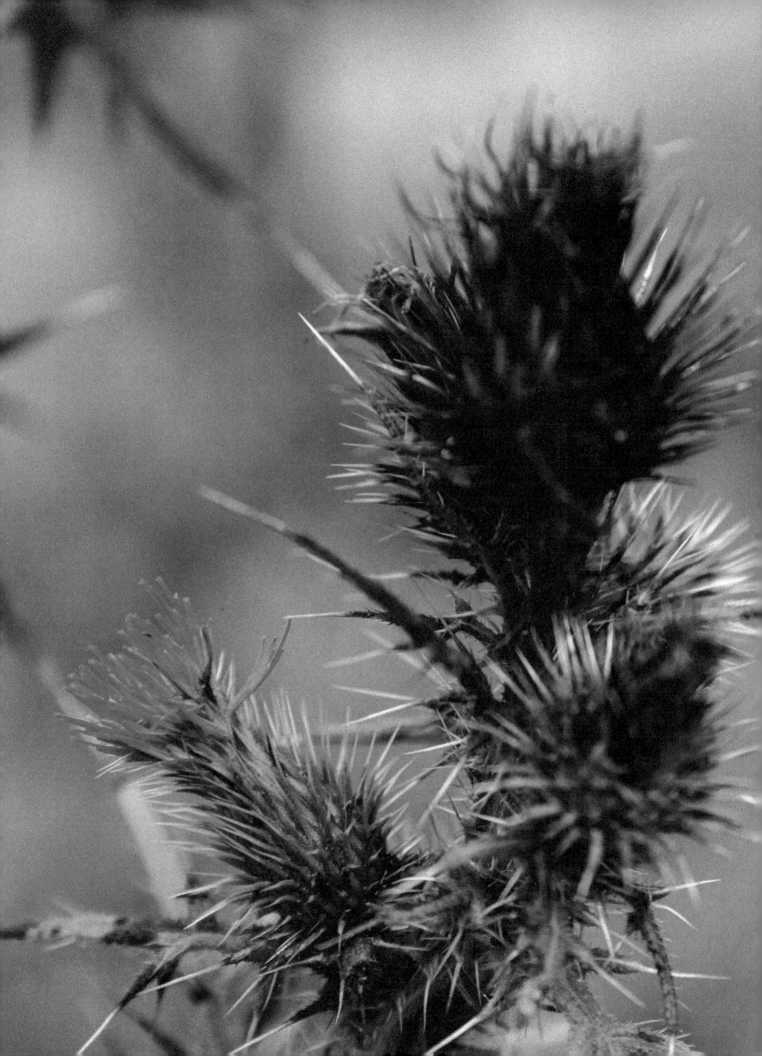

it all goes on
(in a purple heart)

in this evening time
you
come again

a reminder
that
it all goes
on

that summer's dance
is not
all
that there is

take care
o
purple heart

the season
approaching
may be
a hard one

burdened
(into darkness)

the burden is
unspoken
but
I *feel* it
all the same

I carry on . . .

I carry

and I bow
low
but am not
yet
broken

the sky
above -
indifferent to
below -
sails its clouds
into the west

but for me . . .

well
only burden
and
so many
many
miles still to go

into the darkness
before ever
I can rest

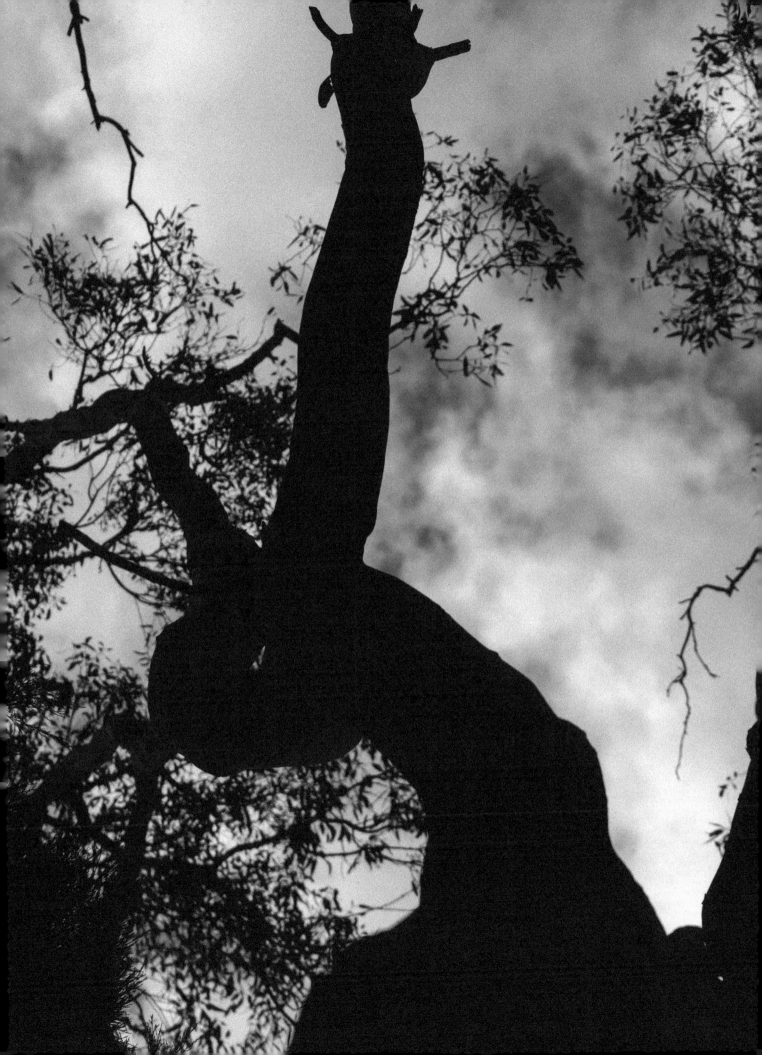

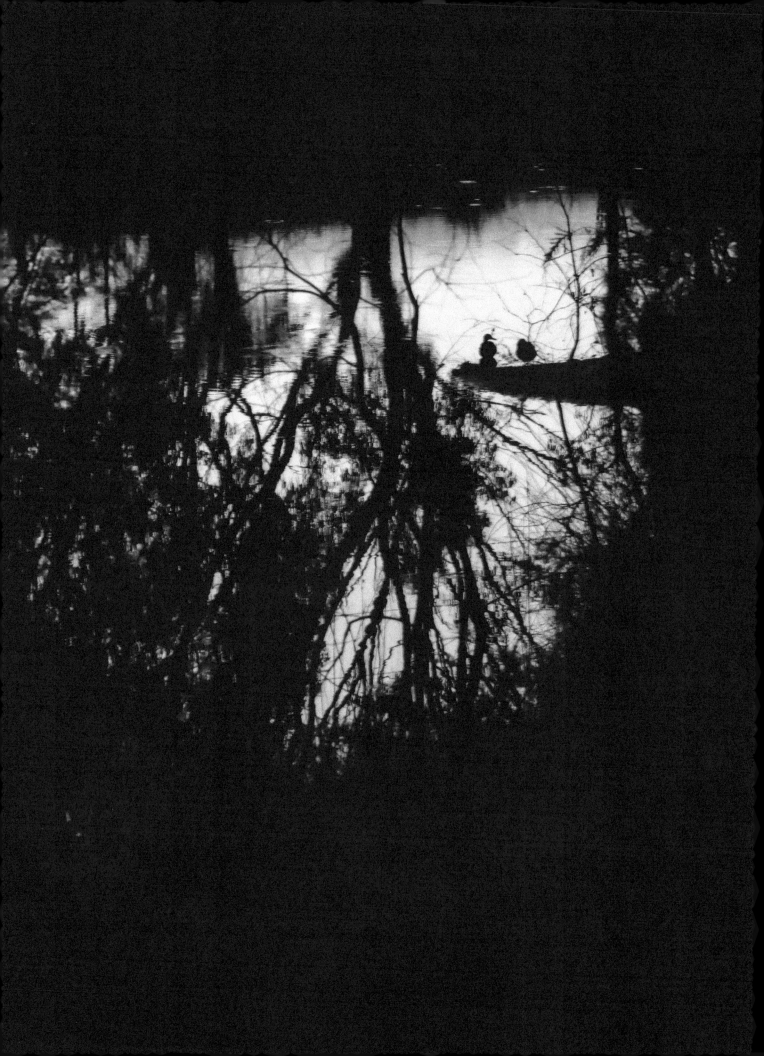

the question is
(goodnight)

is the end
just
end of day?

is the end
the end?

no one can know
until
tomorrow

a day
that never comes

so -
perhaps -
it is just

 goodnight
 my dear

nothing more
than that

I may see you -

if
I see you -

in the morning

we will know
then
that the night
is past

wide
(is true)

wide

wide
is the sky
and small . . .

so small
am I

you journey
there
while I
fly here

I saw you pass
but you . . .

only the sky
is true

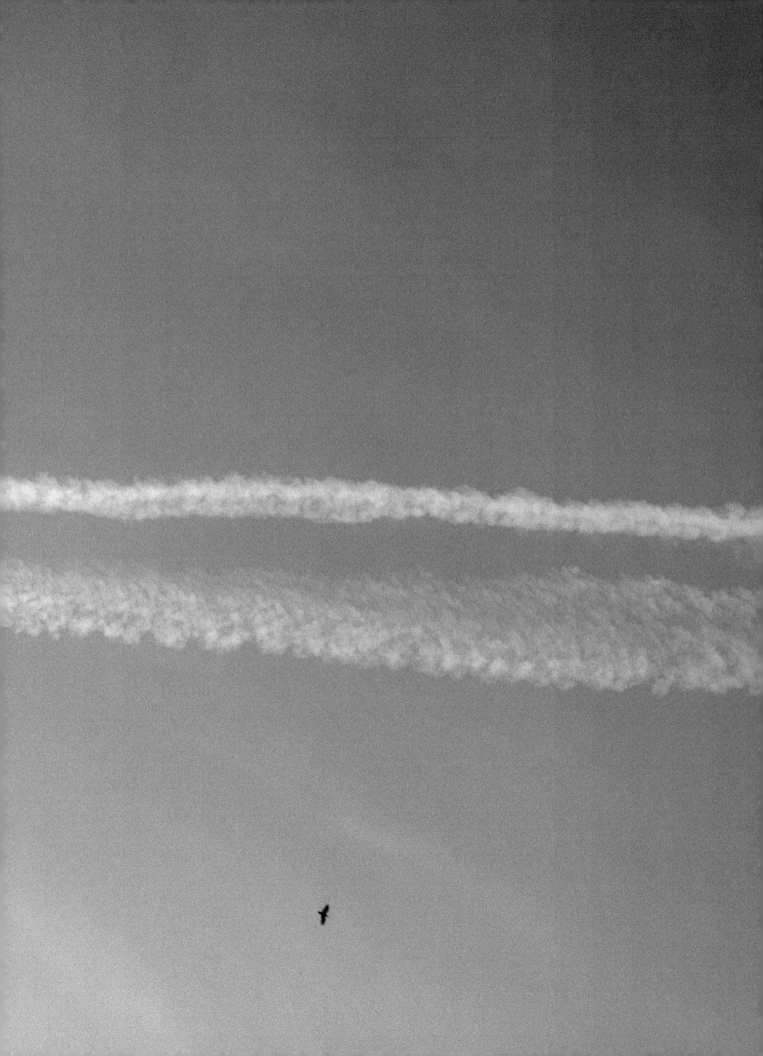

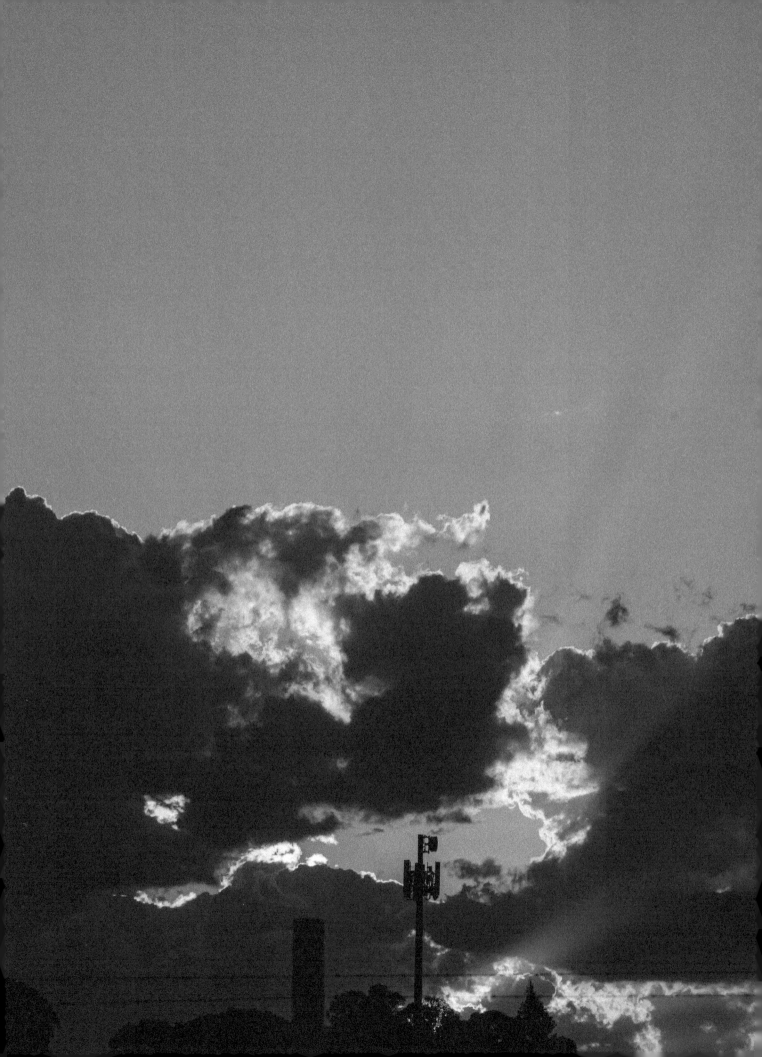

sms
(it is done)

sms
a message
to the sky

 it is night

 it is night

speak
to the darkness
in code

say

 I am
 ready

 day is done

bowing heads
(to the day)

I know
why
the greenhood nods

it bows its head
to the day

worships
the sun
that dapples down
on
the forest floor

golden light
and golden warm

I bow my head
to
the day

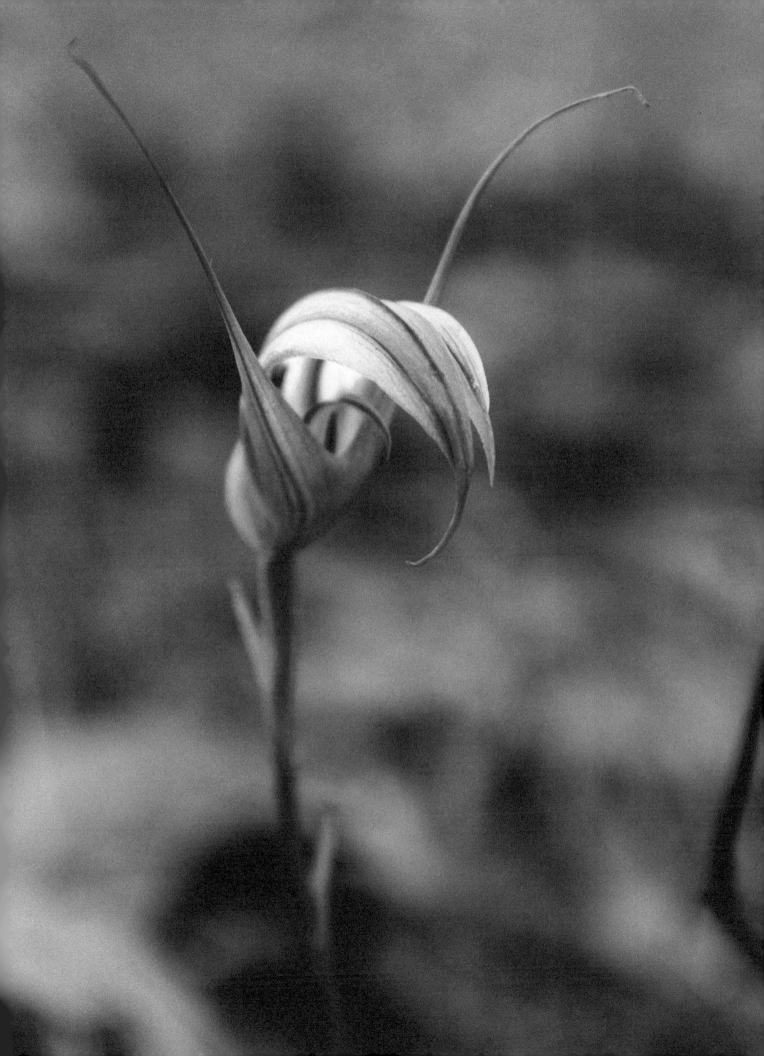

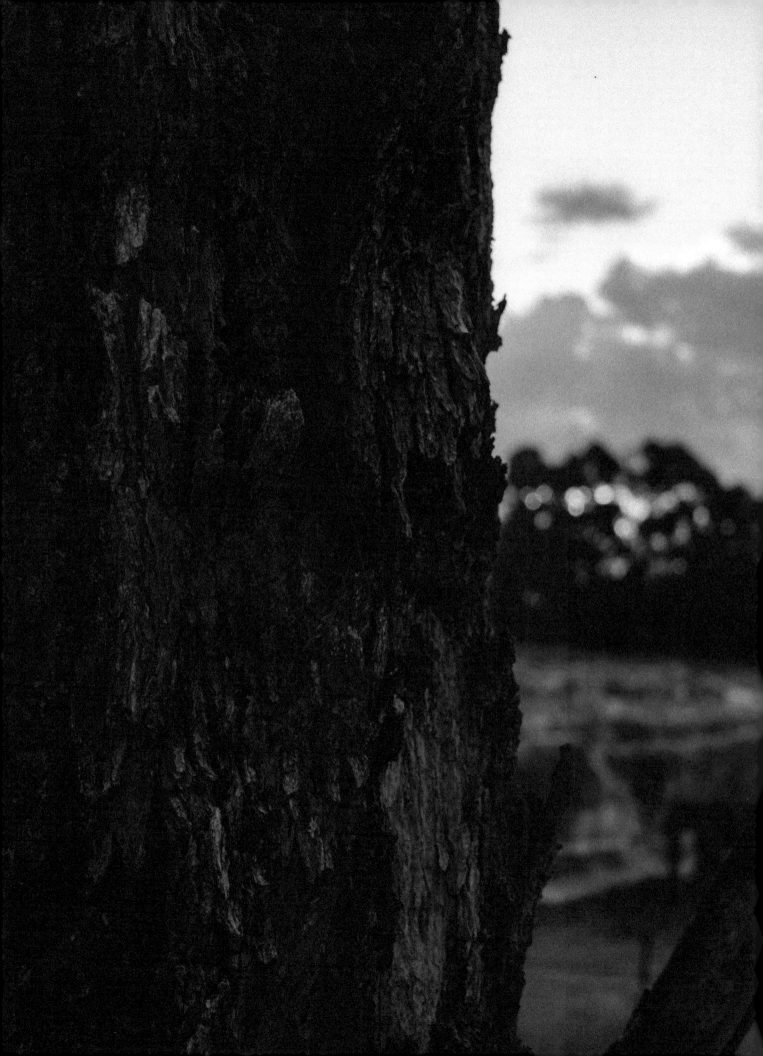

you
(by touch)

your texture
is before me

now

here

when I touch
I can feel your age

the life
behind every
contoured crag

a life revealed
by touch
even as the dark
descends

and the sun fades
into distant worlds

I can close
my eyes
and still . . .

I will know
you

until
(the sun returns)

a last display
before
the night

the sun -

to show
its love -

is warm

like a promise
that it will not go
too far

it will not
stay away
too long

goodnight
goodnight
but
only sleep
until
tomorrow's dawn

only dream
until the light
returns

to wake you
in a new-day
glow

when
the sun returns

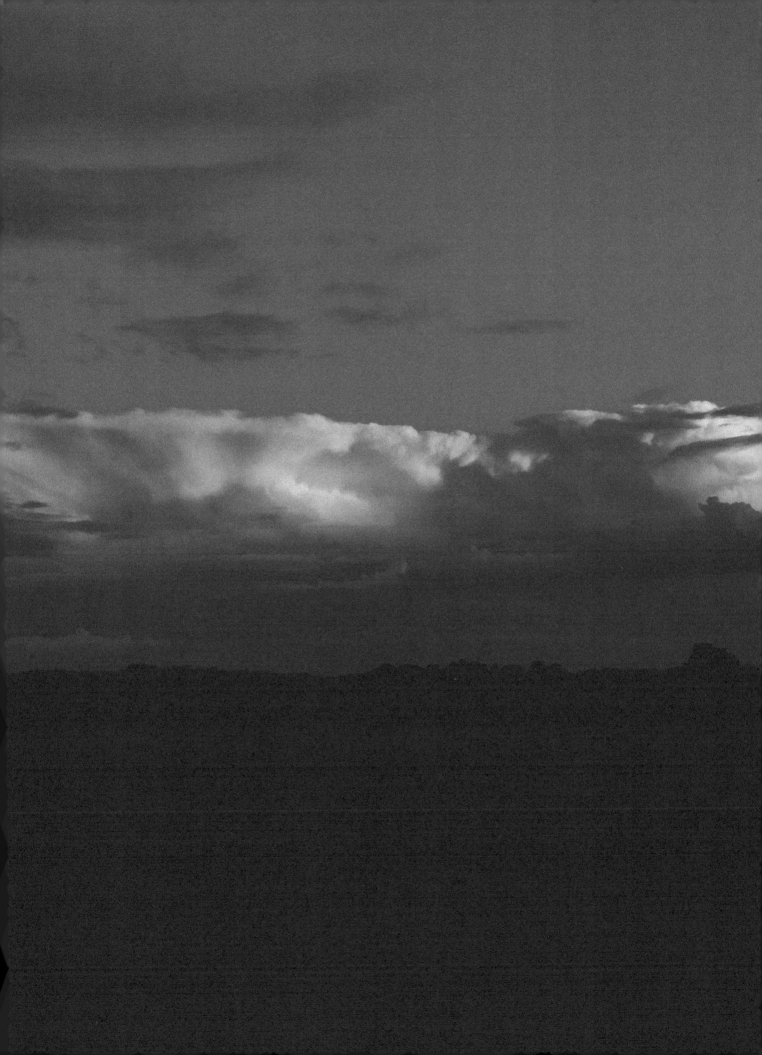

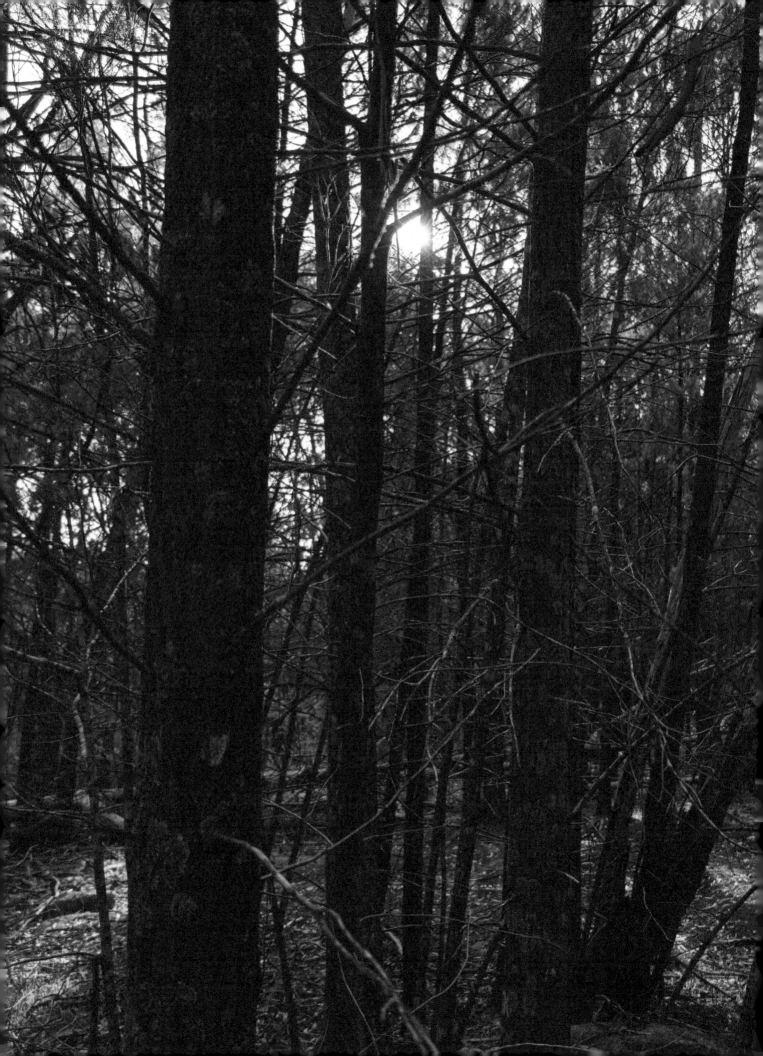

not
(on this road)

look
through the trees
there

can you see
me?

I saw *you*
so nearly . . .

but
it was not meant
for *that* day

that path

maybe those choices
we made
way back
and when

might have led
to fresh meetings
on the path
at *this* time

but
when I looked

there was no one

and even *I*
was not there

that is the way
with young choices
I suppose

and lives
now lived
on this road

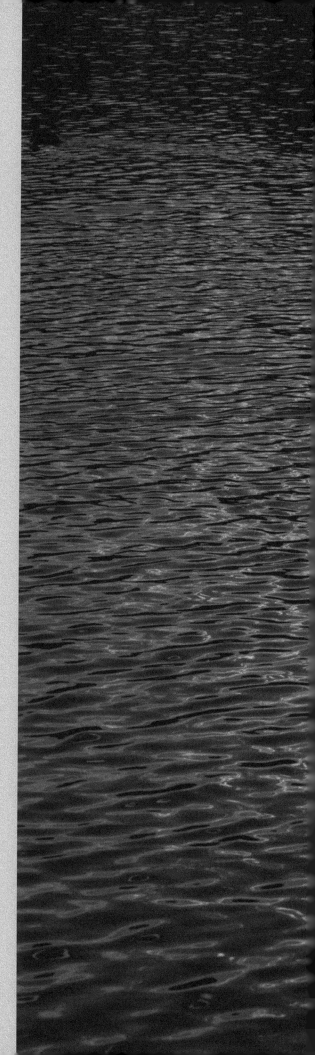

it shines
(on me)

light falls
where it will

it can fall
on water

on ducks and dabs
and water birds

reeds and grasses
and me

light falls
where it wants to

where it will

sometimes
a little light
might fall
right
on me

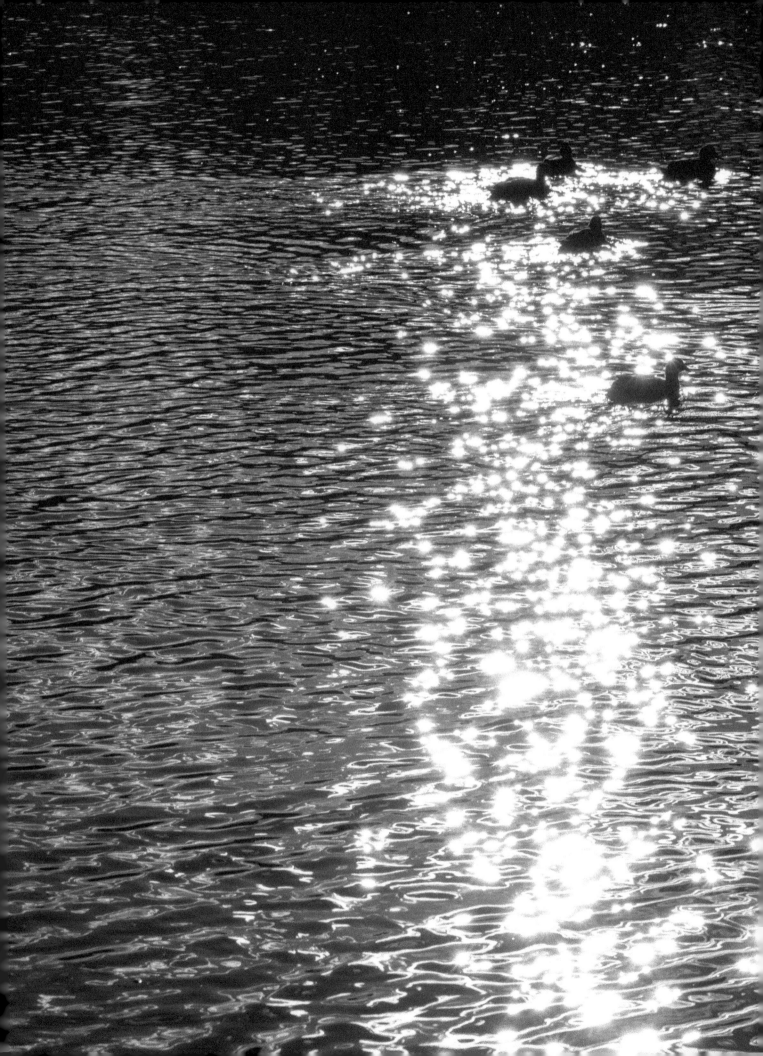

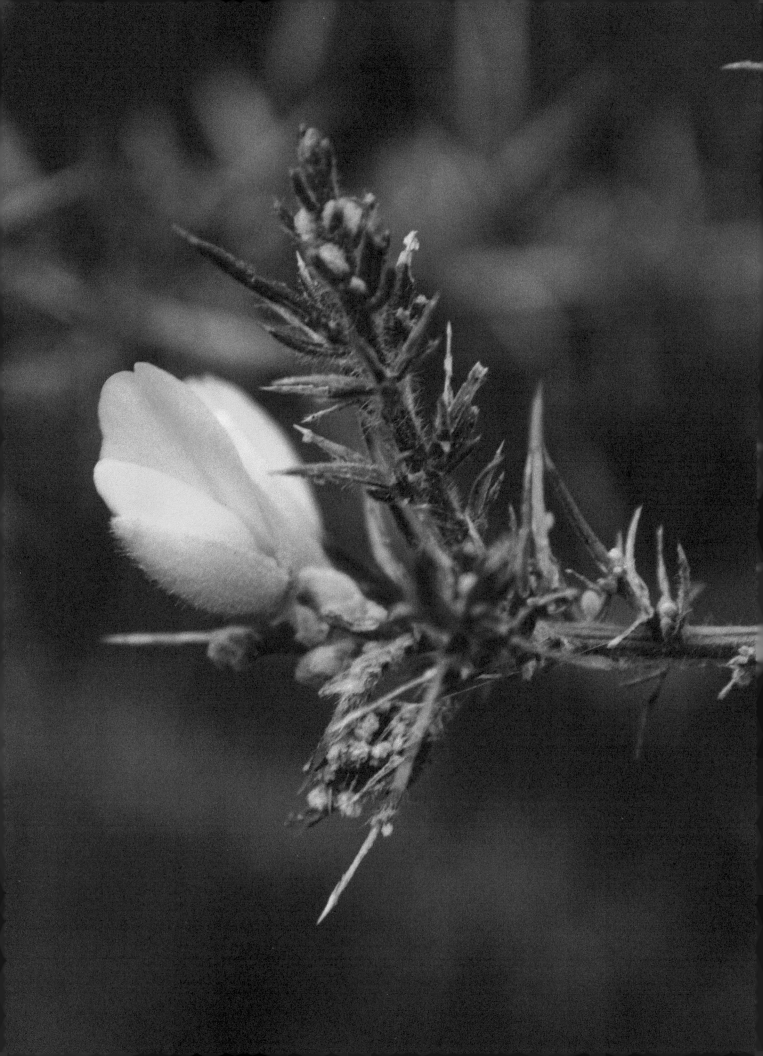

the sweet smell
(of evening light)

and this path
is still
a good one

the journey . . .

worth my while

every step
brings me
closer

to wherever it is
I am bound

thorns
cannot conceal
the flowers

they smell
sweet
to me

I see them
clear

the evening
sheds
revealing light

plainly
(everywhere)

there you are

I see you

will you speak
in great
and thunderous tones
or
will you whisper?

there you are

I see you
plain

even wreathed
behind your clouds
you cannot hide
from me

I see you plain

feel you
in the air I breathe

everywhere

I see you

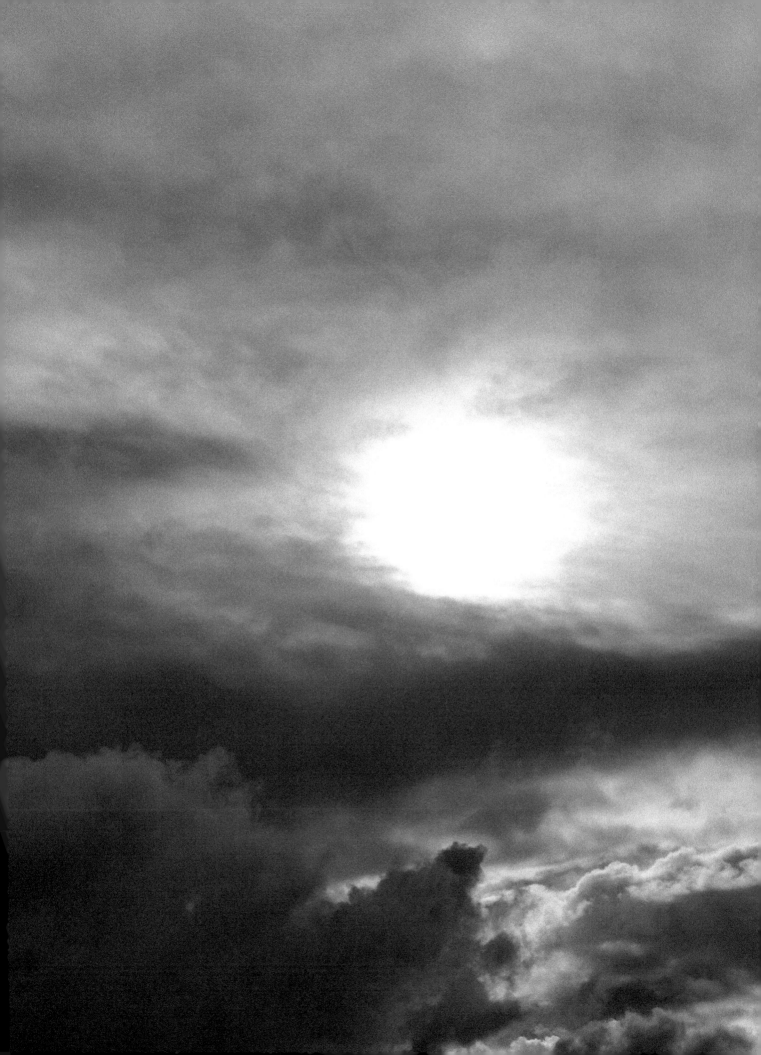

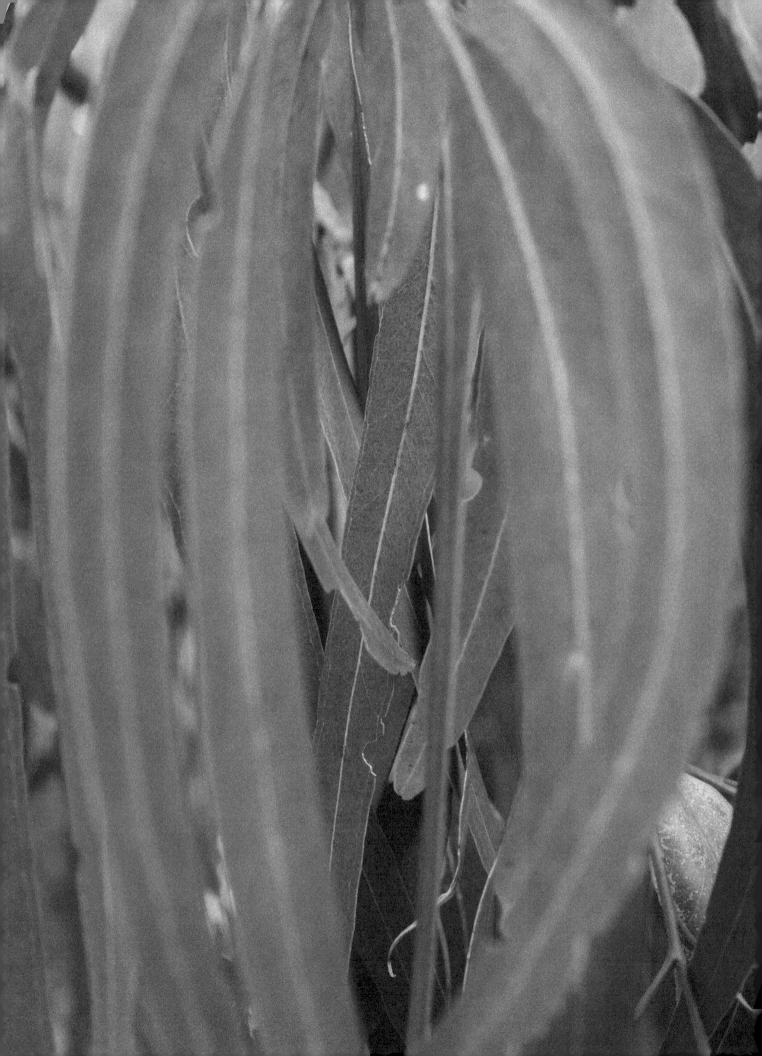

all the same
(different)

to go forward
is

to go
within

beyond the leaves
and layers

all the way
until . . .

another view

another side

everything the same
yet
everything
is so different

a memory
(one day)

cling
to yourself

to
your hope

even this . . .

this
one day

will fade
to memory

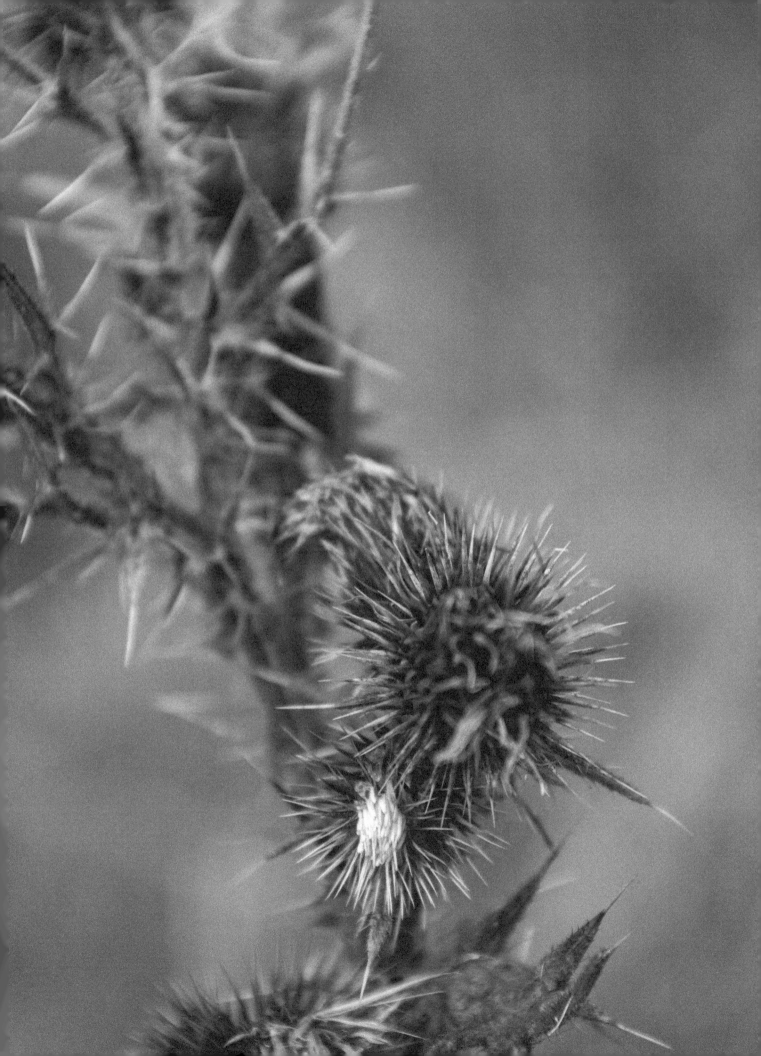

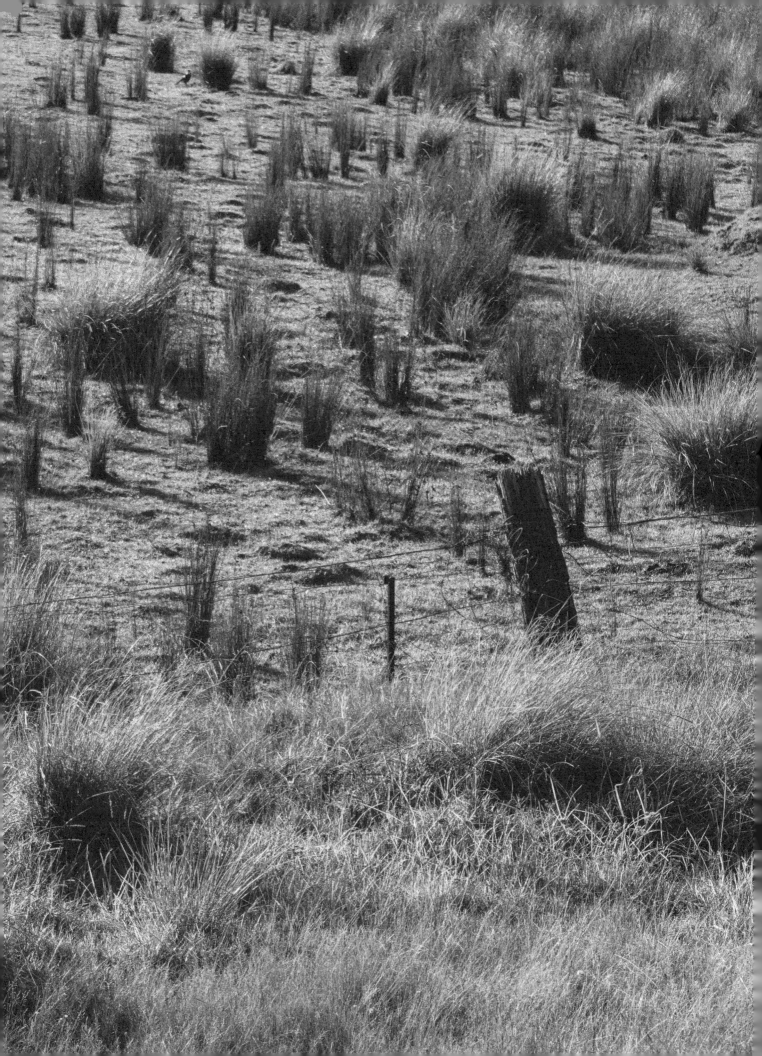

standing
(still strong)

shadows lengthen

still
I stand

leaning

listing

but only
slightly

only
at the margins

my core
is still
as strong
as . . .

still
I am strong

even
as the sun
diminishes
and shadows grow

I stand

**yonder
(is the call)**

yonder
lies
the west
of me

that way
I will go . . .

in time

there is time
yet
for everything

but I see
the way

hear its call

yonder

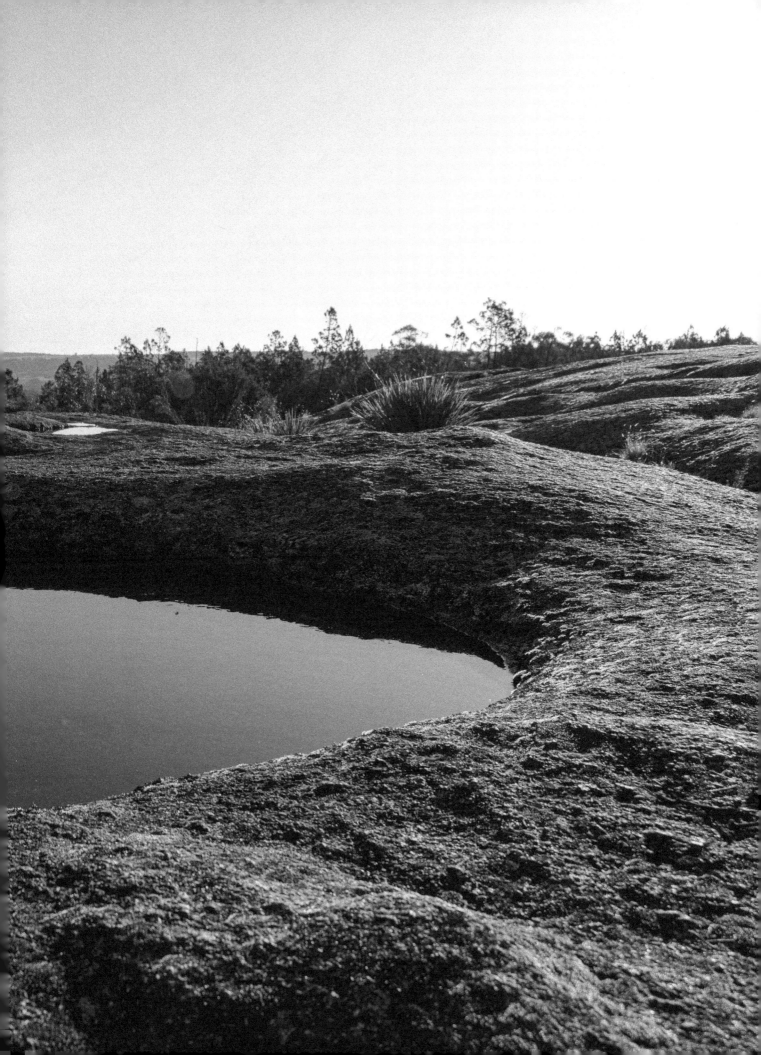

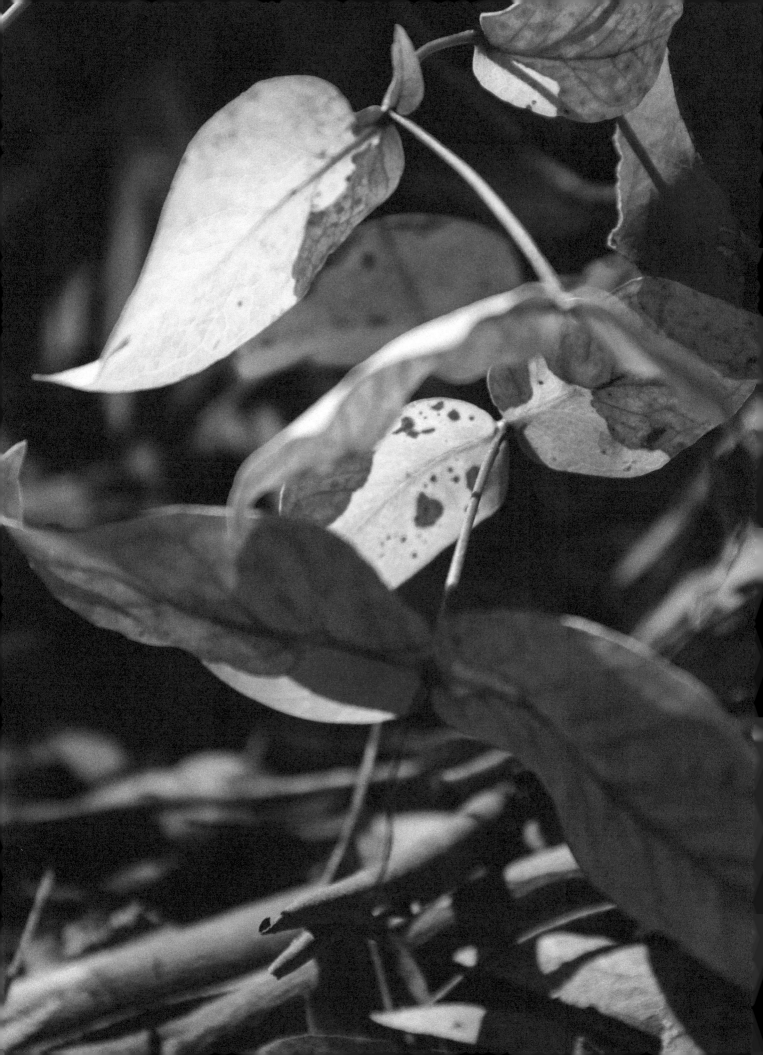

what light
(on you and me)

what
is the colour
of light?

the white
that is the green that grows

the brown
that marks goodbye

what light
is this
that shines on you . . .

that shines
on
me

slow
(too slow)

once . . .

when it was springtime

new morning

I lived -
oh
how I lived -

a simple life
and a wildness
freed

I am . . .

tamer
now

tangled more

not so certain
where
my feet should go

they lead
and I still follow
but

one day . . .

it may be soon

I will slow
enough
to be *too slow*

and all that I
have left behind

will walk with me
again

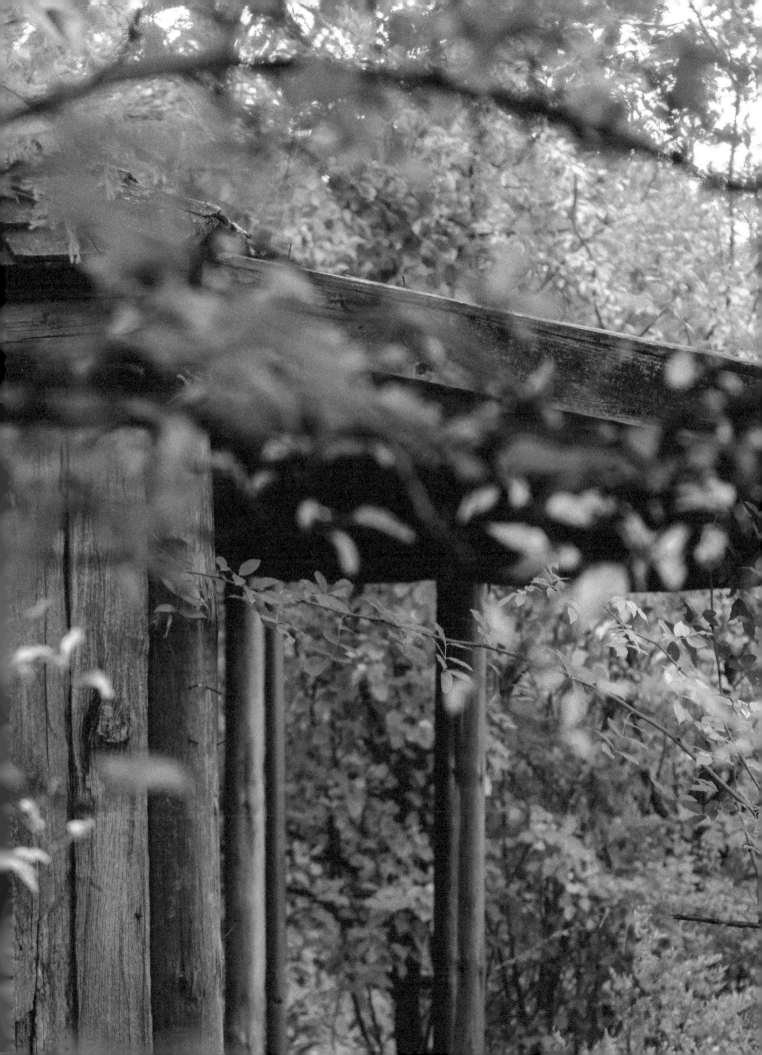

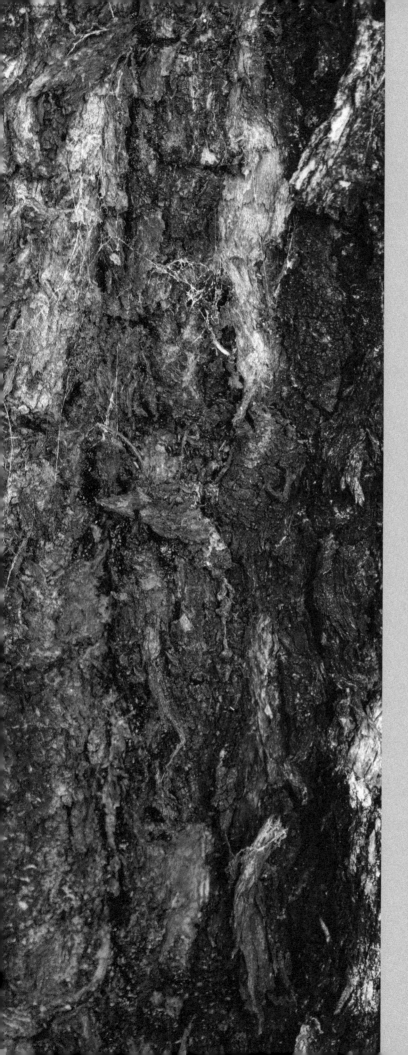

bowed and bended (gnarled)

old gnarl

I know you

we have met
along the way

you stand tall
yet

I
am bended

by the storms
within my life

bowed down
by the wind

old gnarl
do you recall
my face?

I
have dwindled
you
have grown

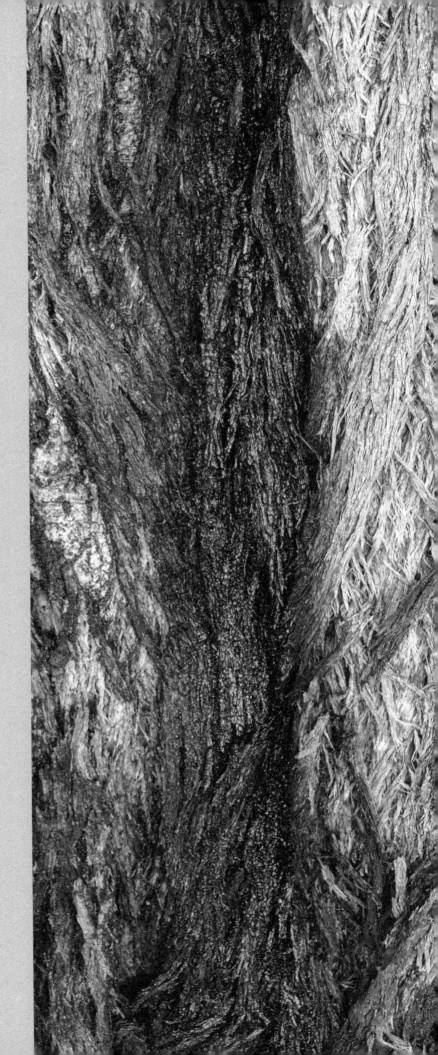

marked
(we are old)

we are
marked

you
and I

each breath
exacts a toll

a body
has to pay
the price
of life

days are short
the toll
is high

or
so it seems to me
some days

becoming elder
while we looked
away

just what
is that?

I
do not know

but we are marked
now
you and I

like all who live
we are
grown old

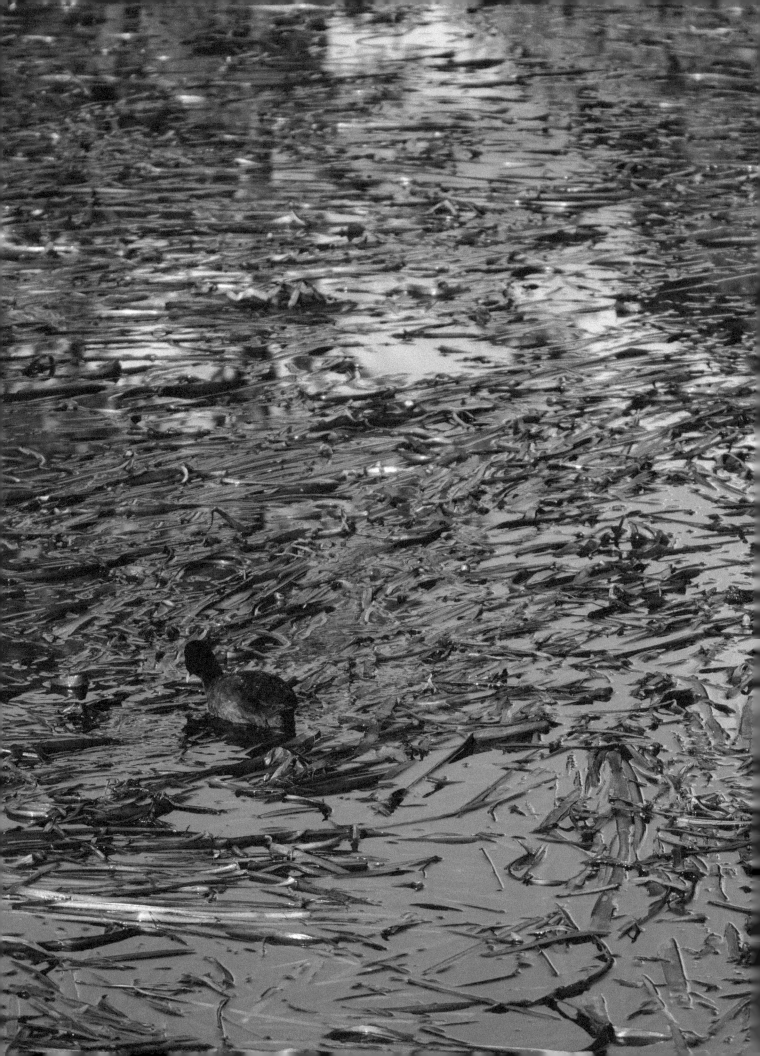

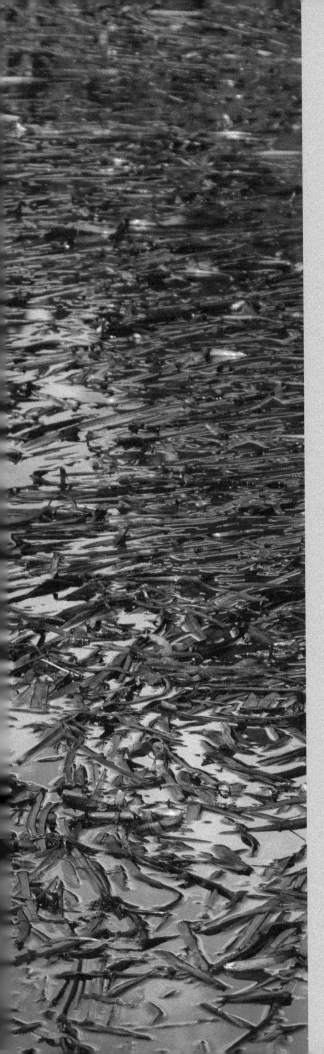

this is mine
(it is the reason)

the weary work
goes on

all the day
until
the sun
is down

I am not spared
from my tasks
though the shadows
grow

light
is life
and life
is work

there must be
a reason

this
is mine

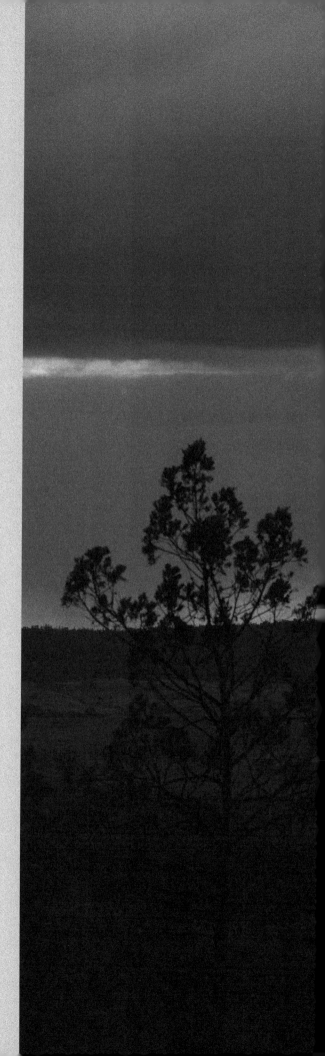

etching
(a day)

draw in lines
across the sky

draw
in rays
descending

pastel
the clouds
in shades of light
and darker greys

bright
the horizon

the painting of the day
is done

the painting of this day
has been drawn
and brushed
and pastelled on its canvas

the artist
has packed her things

gone home to bed

and I
will follow now

her canvas etched
inside

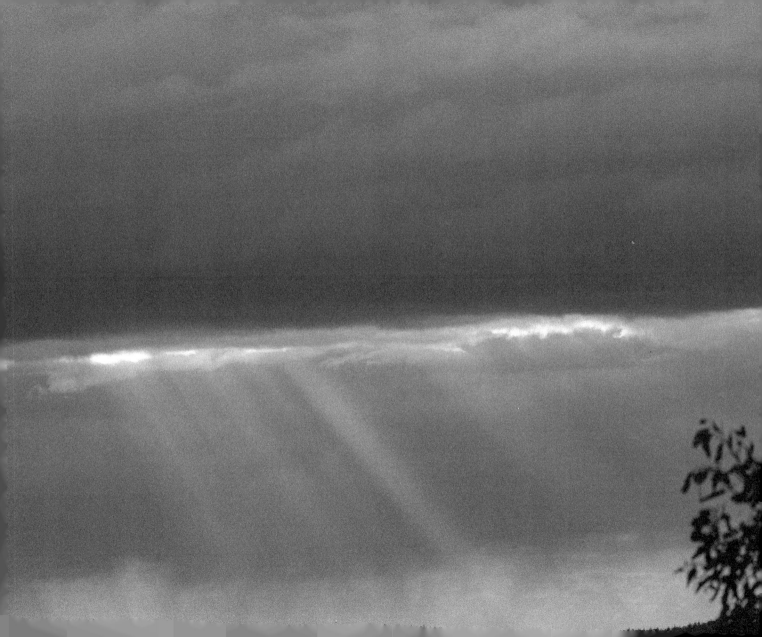

Author Information

About the Author

Frank Prem has been a storytelling poet since his teenage years. He worked as a psychiatric nurse through all of his professional career, stretching to forty years.

He has been published in magazines, online zines, and anthologies in Australia, and in a number of other countries, and has both performed and recorded his work as spoken word.

He lives with his wife in the beautiful township of Beechworth in North East Victoria, Australia.

Connect with Frank

As the author, I hope you enjoyed this volume of poetry collection. I think that mine is a unique style of writing that can appeal well beyond a *'pure poetry'* readership.

If you enjoyed it, I'd like to ask you to do two small things for me.

First leave a short customer review of this book with your preferred online retailer.

Online reviews provide social proof to readers and are critical to Indie authors such as myself.

The second thing is, please pop over to my author page www.FrankPrem.com, and subscribe to receive my occasional Newsletter.

From time to time I'll let you know what is happening with myself and my writing, as well as keeping you informed of any giveaways I may be planning.

Other Published Works

Free Verse Poetry

Small Town Kid (2018)

Devi l In The Wind (2019)

The New Asylum (2019)

Herja, Devastation - With Cage Dunn (2019)

Walk Away Silver Heart (2020)

A Kiss for the Worthy (2020)

Rescue and Redemption (2020)

Pebbles to Poems (2020)

The Garden Black (2022)

A Specialist at The Recycled Heart (2022)

Ida::Searching for The Jazz Baby (2023)

From Volyn to Kherson (2023)

Alive Is What You Feel (2023)

Picture Poetry/Spoken Image

Voices (In The Trash) (2020)

The Beechworth Bakery Bears (2021)

Sheep On The Somme (2021)

Waiting For Frank-Bear (2021)

A Lake Sambell Walk (2021)

A Few Places Near Home (2023)

What Readers Say

Small Town Kid

A modern-day minstrel. Small-Town Kid is a wonderful collection.
—S. T. (Australia)
A poet's walk through his childhood in a small Australian town.
—J. L. (USA)

Devil In The Wind

Instantly grips you by the throat in his step-by-step story of survival.
Bravo!
—K. K. (USA)
Outstanding!
—B. T. (Australia)

The New Asylum

Words can't do justice to the emotional journey I travelled in (reading this collection).
__C. D. (Australia)

If I had to pick one book over the past year that has truly resonated with me, this would be it.
__K. B. (USA)

Walk Away Silver Heart

Has an extraordinary way with words and his poems invoke great passion and emotion in the reader.
—R C (United States)

As Memorable as My Favourite Music
—M D (United States)

A Kiss For The Worthy

A Celebration of Life Written in Thoughtful Bursts of Poetic Expression
—C M C (United States)
With every verse, I found myself reflecting about myself, my life, and the world.
—K

Rescue and Redemption

The passion of love in its many forms explored by one for another.
—J L (United States)
I've enjoyed every word, every breath. Every moment within the life of these stories.
—C D (Australia)

Herja, Devastation

Simply written, powerfully felt.

__C. (Australia)

As a combination of poetry, prose, and wonderfully ominous illustrations, I found Herja, Devastation refreshingly original.

Highly recommended!

—G. B. (AuBravo!

Outstanding!

—B. T. (Australia)

Index of Individual Poems

www.FrankPrem.com

Milton Keynes UK
Ingram Content Group UK Ltd.
UKHW050739141223
434282UK00009B/89